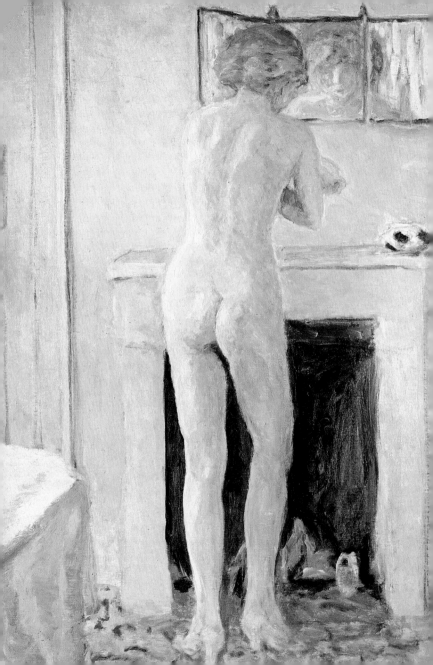

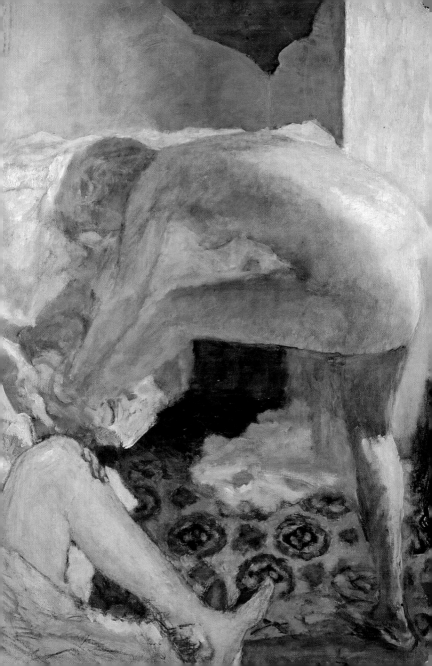

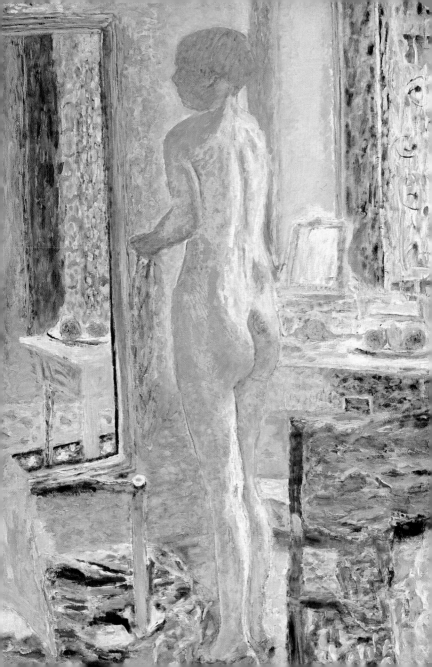

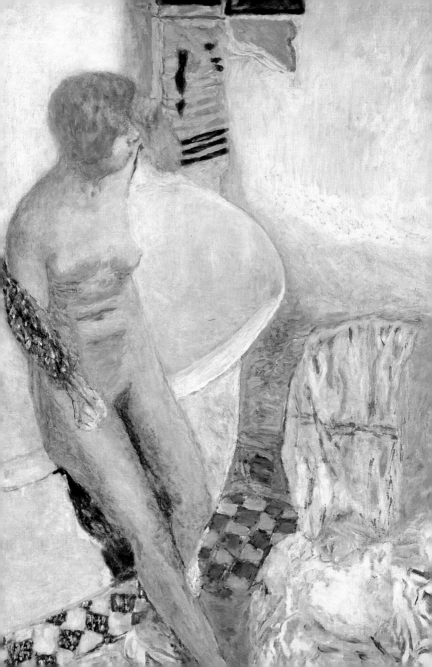

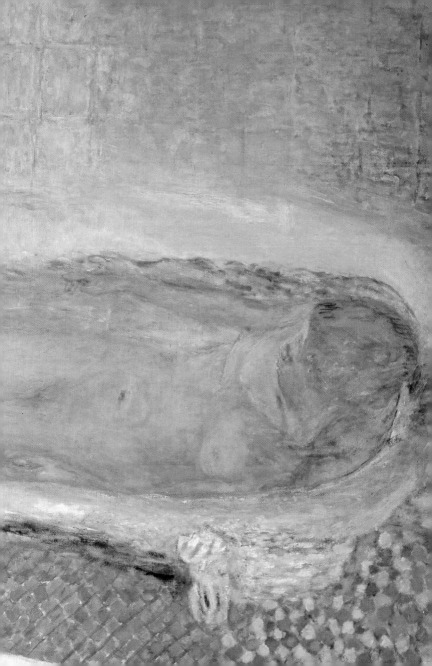

CONTENTS

BONNARD
SHIMMERING COLOR

Antoine Terrasse

DISCOVERIES®

HARRY N. ABRAMS, INC., PUBLISHERS

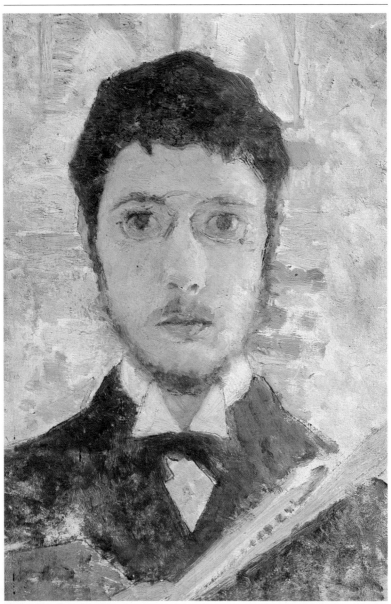

"What attracted me was less art itself than the artist's life and all that it meant for me: the idea of creativity and freedom of expression and action. I had been attracted to painting and drawing for a long time, but it was not an irresistible passion; what I wanted, at all costs, was to escape the monotony of life."

Pierre Bonnard

CHAPTER 1
THE EYE OF A PAINTER

Left: this first *Self-Portrait* was painted in 1889, when Bonnard was 22 and a student at the Académie Julian. His look is intense behind his wire-framed pince-nez. Right: *The Delivery Cart,* drawn in pencil and pen on paper, is from one of his first sketchbooks, and dates to about 1885–88.

Pierre Bonnard's life as a painter developed slowly, steadily, and with quiet independence. He felt that a sense of freedom and detachment was essential to the creation of art. "I belong to no school," he proclaimed at age 24. "I seek only to produce work that is personal." In his eightieth year he still maintained this position, declaring, "In art, only the reactions count." Yet this desire to

A bove: a portrait of *Pierre Bonnard at the Age of Six* by an unknown artist. Left: *Roofs at Le Grand-Lemps,* a youthful, unfinished work, reveals a fine grasp of light and shadow and of color harmonies, showing the artist's early talent. He painted his first landscapes in the Dauphiné, where he spent summers and autumns.

remain somewhat cool and removed was not a sign of indifference or lack of passion.

His father was from the Dauphiné and his mother from Alsace—two provinces with great character. Pierre, the second of three children, was born on October 3, 1867, in Fontenay-aux-Roses, a village just outside Paris

known for its cultivation of roses. His father, Eugène, was bureau chief of the war ministry and a great lover of gardens. The Orsay railroad line, still quite new, provided direct access to the city.

Pierre, his elder brother, Charles, and his younger sister, Andrée, spent their childhood mainly in Fontenay and Paris. They were, however, familiar with the country and its animals from an early age, for the family gathered each summer in the Dauphiné, at a country house called Le Clos ("the orchard"), in the village of Le Grand-Lemps that had been the home of Eugène's father, Michel, a farmer and grain merchant. This old house had a large garden and an adjoining farm. Pierre was an active child who observed the world thoughtfully through large black eyes.

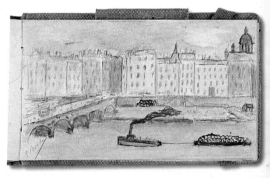

The Seine in Paris, a watercolor painted by Bonnard when he was 14, is his first depiction of the capital. The delicate shades of this small work reveal the quality of his eye. He was living in the city with his grandmother at the time, and often jotted down notes in pen or pencil about various aspects of life in Paris.

Following elementary school in the town of Vanves, he attended the prestigious Parisian high schools Lycée Louis-le-Grand and Lycée Charlemagne, where he was an excellent student. He enjoyed studying literature, Latin, Greek, and philosophy, and showed a great interest in drawing and color.

"I plan to paint from morning til night"

He completed secondary school in 1885 and, obeying his father's wishes, enrolled in law school, receiving his degree in July 1888. But beginning in 1887 he also took art courses at the Académie Julian, a well-known and rather experimental art school in Paris. He also applied to the Ecole des Beaux-Arts and was accepted. He later said that his attendance at classes there was "intermittent"; nevertheless, he met a remarkable group of young artists at the Académie Julian, including Paul Sérusier (1863–1927), Maurice Denis (1870–1943), Ker-Xavier Roussel (1867–1944), and Edouard Vuillard (1868–1940). These four became lifelong friends of his.

Only during vacations at Le Grand-Lemps was he able

to devote himself to painting. Once he had completed his law studies, however, he began to long for time to make art. On July 20, 1888, he wrote to his mother: "I feel a true sense of deliverance and the greatest elation at the end of my studies. Do not imagine that I am coming to Lemps just to sit around and observe. I am going to bring a load of canvases and pigments and I plan to paint from morning til night." The small landscapes he made in the Dauphiné at this time have lovely light, delicate tones, and call to mind some of Camille Corot's paintings of Italy.

A talisman

That fall, back in Paris, he was happy among his peers at the Académie Julian. Vuillard soon became the artist to whom he felt closest. His humor and cheerful disposition drew the two closer together, and they shared a certain inner reserve. Meanwhile, Sérusier had spent the summer of 1888 in Brittany. Returning to Paris, he showed them all a small painting that he had done at the town of Pont-Aven, under the influence of an artist he had met there, a 40-year-old painter named Paul Gauguin (1848–1903). The little work, done on the wooden lid of a cigar box, astonished and disturbed them: its forms are schematic and nearly abstract, composed of planes of intense, flat colors from which a landscape emerges—a few trees of the Bois d'Amour woodland, reflected in a river. This painting was all the more remarkable to the group since they had not yet seen the works of the Impressionists. They called it their "talisman," and it is sometimes titled *The Talisman*.

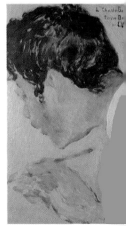

Above: *Bonnard in Profile*, 1891, by Edouard Vuillard. Below: a sketch by Bonnard of students at work at the Académie Julian. He places himself is at his easel at center; seated to his left is Paul Sérusier, manager of the studio.

At the end of 1888 Gauguin exhibited work in Paris. Led by Sérusier, the novice artists of Bonnard's circle discovered other paintings by him, including his famous work *The Vision after the Sermon,* whose intense red fields burn like fire. They also began to look at the works of Vincent

van Gogh (1853–90). Later, at the Galerie Durand-Ruel on rue Le Peletier, they found works by the Impressionist painters—Edgar Degas (1834–1917), Alfred Sisley (1839–99), Claude Monet (1840–1926), Pierre Auguste Renoir (1841–1919), and Camille Pissarro (1830–1903). And then, at Père Tanguy's art-supply store on rue Clauzel, they encountered the even more revolutionary canvases of Paul Cézanne (1839–1906).

The Nabis

Although Bonnard remained an independent spirit, when his friend Sérusier formed a group of like-minded painters, he readily joined it. They called themselves the Nabis. The word is Hebrew, and means "prophets," though the group also used it in the sense of "initiates." They considered themselves initiates because they went in secret to see and learn from the experimental canvases of the Impressionists, who were then causing consternation and outrage in Paris, and whom their teachers were rejecting out of hand. And they were prophets of the even more radical art of Gauguin.

In the spring of 1889 Paris was hosting the great Exposition Universelle, a landmark world's fair mounted in celebration of the 100th anniversary of the French Revolution. For it, Gustave Eiffel (1832–1923) had built his immense 300-meter tower, using innovative cast-iron

"The annual Paris Salon exhibited the works of the most respected artists of the time. A young beginner with no special connections to the art world's revolutionaries could ignore them, for they lived on the margins," Bonnard wrote. Thus, when Paul Sérusier showed his friends his radical little landscape *Le Bois d'Amour (The Talisman),* painted "under the dictation" of the revolutionary Paul Gauguin, it astounded them. They had not encountered Gauguin before.

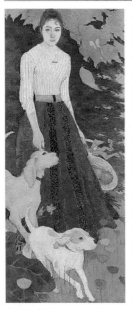

construction, and drawing vast crowds of sightseers. Gauguin made the most of the press of visitors to the tower by showing his most recent paintings at the nearby Café Volpini, along with those of some of his friends. "We carried our own canvases," wrote the painter Emile Bernard (1868–1941). "Gauguin pulled the cart and we pushed from behind."

Maurice Denis, another member of the group, later recalled the general excitement elicited by Gauguin's revelatory paintings: "Instead of opening windows upon nature like the Impressionists' paintings, these works had heavily decorated surfaces, powerfully colored and sharply defined by a strong brushstroke. Like cloisonné enamel." For the Nabis, Gauguin's Café Volpini exhibition confirmed the ideas they had first seen expressed in Sérusier's small Pont-Aven landscape. To exalt color and simplify forms with a brushstroke that accentuates their character became their rule. This was, one may say, the debut of the Nabis as a group, which grew to include Bonnard, Bernard, Denis, Sérusier, Vuillard, Félix Vallotton (1865–1925), and Roussel. As had the Impressionists, they faced comprehensive rejection by the powerful official art world.

"Waves of green, blue, and yellow"

Yet initially Bonnard had resisted the precepts of his companions. At Le Grand-Lemps during the summer of 1889 he embarked upon his first large-format canvas, a portrait of his sister called *Andrée Bonnard with Her Dogs,* on which he worked for many months. It shows remarkable early skill, but reveals little influence of Gauguin or the Nabis. He was then 22 years old and pursuing the semblance of a law career, working part-time for the treasurer of the records office of Courbevoie,

Left: Bonnard began this portrait of his sister, *Andrée Bonnard with Her Dogs*, in 1889. Returning from the orchard, the young girl is accompanied by her pets Ravageau and Bella, who run around her. The colors are bright but refined. The draftsmanship, skillfully simple, does not accentuate form, but lends a sense of movement to the whole. The elegance of the line and the equilibrium of the painting's proportions offset the decorative flatness of the flowers and foliage.

a Paris suburb. But all he wished to do was paint, and he dreamed only of colors. Though he became a licensed attorney at the end of the year, he also rented his first studio at 14 rue Le Chapelais in the Paris district of Batignolles. At the end of December he planned a visit to the resort town of Arcachon with his friend and future brother-in-law Claude Terrasse, a young composer. He wrote to Andrée, "I'm bringing my box of pigments; waves of green, blue, and yellow will flow, each in turn. Arcachon: four patches of color—the dark green of the fir trees, the light green of the sea, the yellow of the sand, and the blue of the sky. One has only to change the sizes of the patches to create twenty different views of Arcachon. This is how I imagine that enchanting land."

The year 1890 proved decisive. Now an accredited lawyer, Bonnard was working daily in the Paris law courts, "like a donkey at the mill." While there, he enjoyed sketching other lawyers, judges, and staff. From April 8

In 1890 Bonnard was working in the Paris law courts and frequently sketched his colleagues. Below: *At the Bar* contains scribbled notes about colors, intended for a future painting.

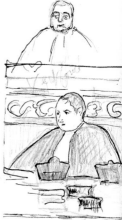

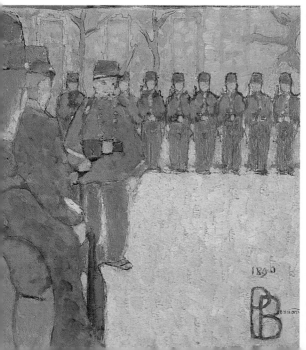

Left: in 1890 Bonnard was a private in the army, stationed in the Isère region. *On the Parade Ground,* a painting of great humor, is one of his first attempts at vibrant colors and an unusual composition. The bright blue tunics and red trousers of the soldiers' uniforms contrast with the ground of yellow and tawny sand. The foreground figures are viewed from behind and delineated with expressive brushstrokes. The inventive cropping of the picture gives it the air of a detail of a larger work or group of works.

through May 24 he completed his obligatory two months of military service as a soldier second class in the 52d infantry regiment in Bourgoin. This is the setting for his small painting *On the Parade Ground,* one of his first attempts at handling pure tones.

The Salon des Indépendants

In 1884 experimental artists rejected by the all-powerful

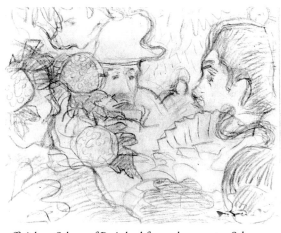

official art Salons of Paris had formed a counter-Salon called the Salon des Indépendants, at which they were able to display their work. Younger artists such as the Nabis greatly admired this venue. Bonnard saw the Indépendants as a means to escape the legal profession, and longed to exhibit work there. The next Salon was to be held in March 1891. During the summer of 1890 he began a series of small-scale studies, as well as a large multipanel screen called *Women in the Garden.* He made two versions of this and finished the second just in time to submit it for inclusion. His work was accepted. "On Sunday I brought my paintings to the exhibition," he wrote to his mother on March 13, 1891. "There will be five, plus four decorative panels. The screen has been dismantled. I made it into four separate panels. They look better on the wall. It was too much painting for a screen." The five individual paintings were the large portrait of his sister, *On the Parade Ground, The Good Dog, Study of a Cat,* and *Afternoon in the Garden.*

Left: an 1891 pencil study for *Afternoon in the Garden.* Bonnard always kept this drawing, since the painting had been bought by the painter Henry Lerolle (1848–1929) at the Salon.

Right: *Afternoon in the Garden* depicts the family gathered in the garden of Le Clos at Le Grand-Lemps. Bonnard's sister is at right; his father, wearing a large straw summer hat, is at center. The painter himself appears in the upper right corner. The composition is oddly compressed: the six figures are squeezed together and can be discerned through the flowers and foliage only bit by bit. Touches of a Japanese influence on Bonnard's style are already apparent in the simplicity of the subject, a taste for the fragmentary, absence of depth, and the sense of silhouetted forms arrested in mid-motion. There is much tenderness beneath the irony and humor of these little family scenes.

The four decorative panels that had originally comprised the screen are particularly important. Their setting is the garden at Le Grand-Lemps. The four figures of young women are based on Bonnard's sister and their cousin, Berthe Schaedlin. Their portraits are drawn with rapid, confident gestures. The supple lines of faces and bodies, sketched in a quick, circular movement, are reminiscent of Japanese drawings and woodcuts, which were then very popular in Paris. The repeated motif of polka-dotted and checked fabrics also evokes a Japanese taste for patterned and embroidered fabrics. Indeed, Bonnard transposed decorative and pictorial motifs borrowed from both Japanese art and some prints that he and his Nabi friends had been making recently. The narrow vertical shape of the panels also echoes a traditional Japanese for-

Above: a detail of *The Good Dog,* a portrait of Ravageau. His name is written at the top of the painting.

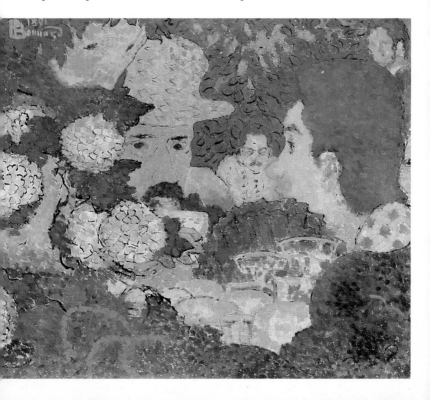

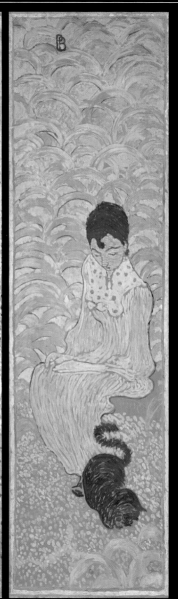

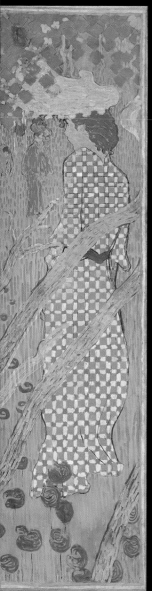
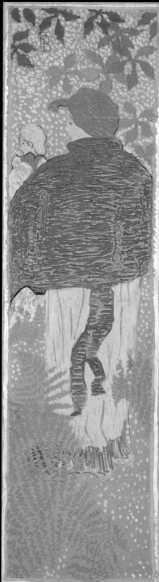

The influence of Japanese wood-block prints on Bonnard is clear in *Women in the Garden,* a large composition of four panels that he began in 1890.

"In a department store, for a few pennies, I found some [printed] crepe paper or crinkled rice paper in stunning colors. I covered the walls of my room with this bright, naive imagery. In fact, Gauguin and Sérusier have mentioned this in the past. But these things that I had there in front of me were extremely skillful and lively. I understood immediately from those crude images that color could express anything, without needing modeling or [three-dimensional] relief. It seemed to me then that it was possible to translate light, form, and character with nothing more than color."

Pierre Bonnard to
Gaston Diehl, 1943

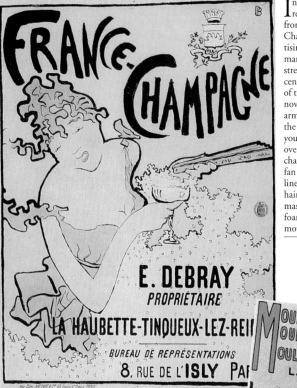

In early 1891 Bonnard received a commission from the firm of France-Champagne for an advertising poster. Although many artists were making street posters in late 19th-century Paris, the design of this one was completely novel. Only the distorted arm and upper body of the figure are visible. The young woman holds an overflowing glass of champagne and a closed fan that serves to underline the brand name. Her hair, ruffled dress, and masses of effervescent foam fill the image with movement.

mat, the *kakemono* scroll, and emphasizes the sinuous arabesques of the forms. Each panel, set off by a matching painted border, possesses its own life and is an independent painting, for despite the shared subjects, the ensemble lacks sufficient visual links to create a sense of unity.

First successes

While he was working on these paintings, he was hired to create a poster for the France-Champagne company, a firm of vintners. Thrilled at this commission, he wrote a quick letter to his mother: "I got a hundred francs.

I assure you, I was proud to have it in my pocket!" At the news, his father danced in the garden. This marked the end of his law career: Bonnard was to live by his art. He rented a new studio in Paris at 28 rue Pigalle, sharing it with Vuillard, Denis, and an actor named Aurélien Lugné-Poë (1869–1940), a companion from secondary school. Bonnard himself loved the theater and was to make numerous designs for the stage. At 24 he was tall and thin, with a mustache and a short beard. Behind the metal circles of his pince-nez, he wore an extremely intense look. He worked happily with his friends in the rue Pigalle studio. "We were four, together, like sergeants," he later wrote.

His entries at the Salon des Indépendants were noticed by a young critic and political radical named Félix Fénéon (1861–1944), soon to become influential among the younger generation of Parisian artists. Fénéon was not entirely enthusiastic (though he was to become Bonnard's close friend); he wrote, "Whether designing a poster or painting the panels of the screen that were on view at the Pavillon de la Ville de Paris this April, Mr. Pierre Bonnard likes to develop his composition behind an arabesque motif that tends to obstruct it."

The poster for France-Champagne reveals both great innovations and a turn-of-the-century taste for dancing, curvilinear lines. What was the source of this vogue, which was to develop into the decorative style called Art Nouveau? In part it arose from a new interest in Japanese art, which had begun to reach Paris after Japan began trading with the West in the mid-19th century. Yet Bonnard's work is remarkably austere. It uses only three colors, all versions of yellow, punctuated by black. And the layout is utterly unexpected, using audacious distortions of the figure and the typography. Bonnard contrasted formal, printed lettering with whimsically curved hand-written text. The France-Champagne poster was his first taste of

Above: Bonnard's decorative illustration for a *valse de salon.* "I have a new commission from the champagne-maker for a cover for some sheet music. It is an advertisement for a *valse de salon,* for which they were asked to compose the music." Opposite, below: Henri de Toulouse-Lautrec's 1891 poster for the Moulin Rouge. Lautrec's clean, sharp line perfectly suits the art of the poster.

the possibilities of color lithography, then a fairly new and mostly commercial process, little noticed by artists.

These new ideas attracted a number of painters, among them Henri de Toulouse-Lautrec (1864–1901), who met Bonnard at this time. The two artists became friends. It was Bonnard who introduced Lautrec to his printer. They soon found themselves competing for a poster commission

for a popular nightclub called the Moulin Rouge. Lautrec won, and began an illustrious career as an artist of posters. Bonnard, recognizing his genius, left the field to him. Or almost.

Art for everyday life

The France-Champagne company, pleased with Bonnard's poster, next commissioned him to illustrate a piece of sheet music that they were sponsoring, a dance called a *valse de salon.* This was his first illustration, though he was to do many more in the course of his career. His later decorative projects included designs for fans, dishes, and furniture. In these Bonnard often reused subjects he had dealt with in his paintings. An example is an image of two dogs at play, which he painted as *Two Poodles* and later used in a sketch for the decoration of a large sideboard.

"Our generation was always exploring the relationship between art and life," he later said. "Personally, during this period I wanted to make artworks for everyday use by ordinary people: etchings, furniture, fans, screens." It is no surprise that both his paintings and his decorative projects

The Checkered Blouse, an early painting from 1892, displays some of Bonnard's most characteristic techniques: the format is tall and narrow, the figure is abruptly cropped on all sides, and the table is tilted away from her so that the objects on it seem to slide away under her gaze. The objects themselves are luscious and alluring: sparkling glassware and bright, indistinct fruit. The decorative quality, exemplified by the flat patterns of the checked blouse and wallpaper, is emphasized. Folds in the fabric are indicated by uninflected brushstrokes that evoke the artist's interest in the naive style of the art of the *primitif* painters. These effects are seen again and again in his paintings—in the pattern of a tablecloth or the tiles of a bathroom. The model is Bonnard's sister Andrée.

In the charming 1891 painting *Two Poodles* (1891) a pair of puppies frolic on a green lawn. The painting is closely cropped, with no horizon, as are the paintings of Gauguin's Pont-Aven style. These two dogs reappear several times in a design for a piece of furniture (below) done the same year for a decorative-arts competition. Bonnard uses a Japanese-style lacquerwork that calls to mind Edo or Meiji period art.

of this time reveal a similar style and spirit. For Bonnard, decoration and high art are not opposed to one another, but complementary.

In December the Nabis had their first group exhibition at Louis-Léon Le Barc de Boutteville's gallery at 47 rue Le Peletier in Paris.

A "mobile and variable" eye

The next Salon des Indépendants took place in March 1892. Bonnard entered two canvases that he had begun the summer before and only just finished, *The Checkered Blouse* and *The Croquet Game*. The former presents some essential characteristics of his painter's vision: a flattened quality created by the red-and-white pattern of the fabric; and the use of a distorted perspective in which we see the young woman full face, while the

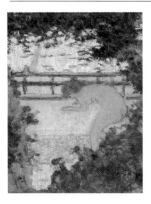

table tilts so that glassware and dishes seem to slide beneath our gaze. These effects draw upon what Bonnard called the "mobile vision" of the eye, which can take in many elements at once. "The eye of the painter gives objects a human value; [the painter] reproduces the things the human eye perceives. And this vision is mobile, and this vision is variable." This rather simple, charming concept of visual interpretation is in some ways naive, similar to that of such *primitif* painters as Henri Rousseau (1844–1910).

The Croquet Game is a large-scale canvas set at Le Grand-Lemps, depicting the Clos garden at sunset—hence its original title, *Dusk*. In it Bonnard condenses all the influences and ideas he had been developing in his first years of painting. At the Salon des Indépendants it received considerable attention.

The Nabi group now began to prepare work for a November exhibition at Le Barc de Boutteville. "I have undertaken two large panels on cloth [canvas]," Bonnard wrote, "*Woman with Ducks* and *The Peignoir*, which I want…to exhibit at Le Peletier." Bonnard later described the first: "A background of velvety white fabric. A woman in somber clothing, her arms hanging, has some ducks at her feet. At the top, a rectangular house with no roof." In the second painting, a narrow vertical canvas, the Japanese influence is still strong: a tall woman, viewed from behind, wears a patterned dressing gown and stands against a patterned background.

Marthe

In 1893 Bonnard met a young woman of 24 named Maria Boursin, though she preferred to use the name Marthe. She was graceful, with pretty hair and periwinkle-blue eyes. "She already had, and always retained, that birdlike quality, with a tiptoe walk," wrote his friend, the critic

L eft: *The Bather*, 1893, is one of the first nudes by Bonnard for which Marthe was the model.

B elow: *The Peignoir,* 1892, once again makes use of a narrow, vertical composition that suggests a Japanese *kakemono* scroll. Bonnard found pictures of such scrolls in the magazine *Le Japon artistique.* The critic Gustave Geffroy rightly describes Bonnard's style here as a "play of symmetrical and contrary lines, entangled and disentangled with charming taste, complicated and surrounded by decorative patterns."

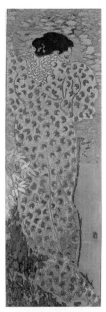

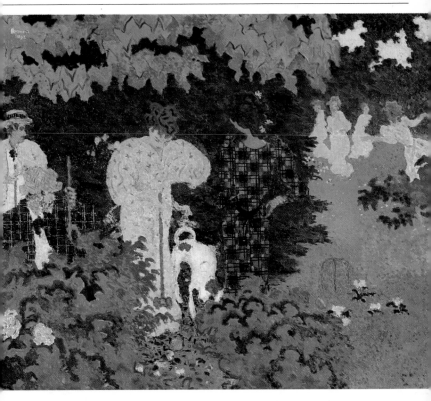

and magazine publisher Thadée Natanson (1868–1951), "a timid air, a fondness for water and for bathing, and a weightless walk, as if she went upon wings." Marthe came to live with Bonnard and he painted her. So began a celebrated relationship between lovers who were also artist and model.

One of his first pictures of her, *The Bather,* shows her nude, walking toward the river's edge near a small wooden bridge. Bonnard used Marthe as the model for an idealized image of a woman, narrow-waisted with high, firm breasts and long legs. Over many years, he painted this slender figure frequently, in varying guises and poses. Indeed, one may trace his evolution as a man and as a painter by observing his many different

The players in the foreground of *The Croquet Game* are all aligned along a horizontal line in a hieratic rendering that owes much to Gauguin. The flat patterns of their clothing, placed on the picture plane like pieces of collage, and the absence of modeling evoke Japanese art. In the background, a circle of young girls in the green grass are once again reminiscent of Gauguin.

interpretations of Marthe: standing, sitting, reclining, or perhaps slipping on a pair of the long black stockings that so stirred the artists of the time.

An artisan of everyday life

Bonnard often painted small genre scenes of Parisian life, using a narrow vertical or horizontal format. He also liked to make much larger decorative works, using multiple panels to depict complex, detailed, panoramic scenes of the city. One such work was a large screen in four sections to which he gave the name *Promenade of Nurses* (now usually titled *Nurses Taking a Walk, Frieze of Cabs*). This presented figures in a broad view of the Place de la Concorde, the vast open central square of Paris, with "a stand of horse-drawn carriages along the top, forming a border." Some years later he reworked the screen as a four-panel lithograph. Another four-panel screen, entitled *Country Landscape,* was inspired by the park at Le Clos. He later separated the fourth

Above: Bonnard in his studio on rue de Douai; behind him is *Child Playing with Sand,* which he had yet to remove from the four-panel screen *Country Landscape,* painted c. 1894. Opposite: the painting depicts one of his sister's youngsters playing in front of the house at Le Grand-Lemps. Below: *Children with a Cat,* an ink drawing. Bonnard portrayed both children and pets frequently.

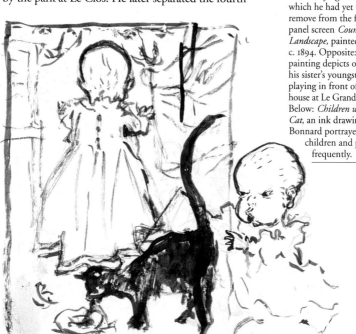

section from the others and titled it *Child Playing with Sand.*

"I have never thought of myself as some kind of genius," he confided to the critic Gaston Diehl. "When I didn't earn enough from painting to live, I did all sorts of work—textiles, screens, furniture. It is when the poet is banished from [Plato's] Republic that he does his best work."

Witness and actor

Bonnard is never as detached from his art-works as he may seem. Humor, irony, and affection for his subjects subtly infuse his images, revealed in an unconventional cropping or an unexpected or comical detail. More than a simple observer and recorder, he is himself an actor in the scenes that he offers to us, inviting us to accompany him on little voyages of discovery. We become passers-by among other passers-by, dodging between the carriages and buses of a crowded street; we smile with him at the tender portrayal of a child.

Innumerable painters before him had translated the life of the great city into paint and canvas. His own art focused on a heightened subjectivity, introducing a psychological analysis into landscapes and urban scenes. He always loved the simple and quotidian—the motion and bustle of life—and often chose it for his theme.

His marvelous drawings are direct, active, vibrant transcriptions of the observed world. The movement of the hand is wedded to the motion of the eye and seeks to capture visual sensations. Bonnard does not draw single, sustained contour lines to define forms; his marks are a quick, open network of energized strokes. His highly personal drawing style translates glimpsed instants onto paper. "[Drawing] is a matter

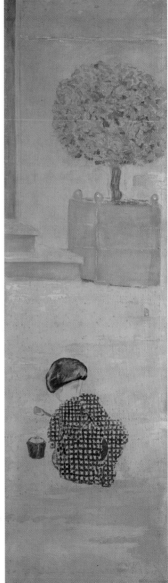

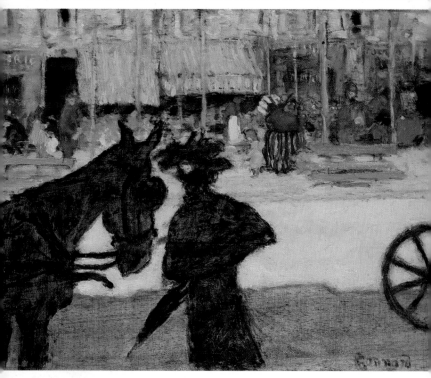

of remembering what you have perceived and recording it as quickly as possible," he commented. This understanding leads to the union of poetic suggestion and precise reportage, which together invite the viewer to explore new worlds.

Prints and paintings

"I did some printmaking this week and I learned many things…I really hope to make the most of them," Bonnard wrote to his parents in 1892. From early on he was interested in all sorts of illustration techniques, including engraving and lithography. In addition to making prints and advertising posters, he experimented with book and magazine design. He drew the cover design for a book by Victor Joze titled *Reine de joie (Queen of*

For Bonnard, who loved images of the passing, evanescent moment, street scenes were an appealing subject. In the foreground of *The Cab Horse* a woman and a carriage horse stand in shadow against the brilliant light of the boulevard. In the background, separated by a band of smooth tan pavement, the colorful life of the city appears. The bit of carriage wheel exiting to the right adds to the animation of the scene.

Joy). The poster advertising the book had been created by Toulouse-Lautrec and was reprinted as the frontispiece. Next, he illustrated a small, fanciful work by Claude Terrasse called *Le Solfège* (*Solfeggio*), drawing on motifs from his paintings as well as from music. The dresses of the female characters, decorated with checks and stripes, symbolize musical tones and semitones; their expressive faces stand out against backgrounds worked in swirls; some of them, intended to indicate the beat of the measure, are placed upon leaves separated like a screen divided into two, three, or four sections.

He let himself dream of future successes: "This will allow me to make a chromolithograph at my own cost and many others, if I have the means, which I will then offer around Paris for a moderate price…That is my vision of the future." He printed the lithograph

Above: this *Family Scene* was published in *L'Estampe originale* in 1893. Bonnard's taste for Japanese style is most visible in his prints. Below: the cover of *Reine de joie: Moeurs du demi-monde*. Today, the book is best-known for Bonnard's cover and the frontispiece by Toulouse-Lautrec.

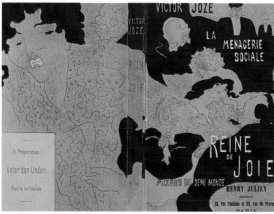

Family Scene in an edition of about thirty, and then several other prints to illustrate his brother-in-law's volumes of music.

At the end of December 1893 Bonnard made a lithograph, *Parisienne Women,* for the experimental magazine *La Revue blanche* (founded in 1889). This marked the beginning of a long collaboration with the journal's publisher, Thadée Natanson, and managing editor, Félix Fénéon. *La Revue blanche* was virtually a salon of the brightest young artists and writers of Paris, many of them drawn to Natanson's "radiant and sibylline" young wife, Misia. (Artists, in addition to the Nabis, included James McNeill Whistler, 1834–1903; Edvard Munch, 1863–1944; and Odilon Redon, 1840–1916; writers included Marcel Proust, 1871–1922; André Gide, 1869–1951; Alfred Jarry, 1873–1907; and Guillaume Apollinaire, 1880–1918.)

The lithograph was followed by another, *Woman with an Umbrella,* depicting a fragile lady in silhouette, picking her way carefully along the street, one hand swinging, the other clutching her skirts. The model is Marthe.

Bonnard's development as a printmaker and poster artist was closely entwined with the progress of his work as a painter. He married his multiple talents and they fulfilled and reinforced one another. "In doing color lithographs, I learned a lot about painting," he later explained to the writer André Suarès. In lithography "one must study the relationship among tones while working with only four or five colors that are either superimposed or set side by

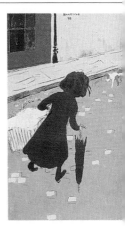

Between 1893 and 1895 Bonnard made lithographs in one or two inks for several magazines, including *La Revue blanche, L'Epreuve,* and *L'Escarmouche.* In 1896 he began to make color lithographs, using more inks, for suites of prints published by Ambroise Vollard. Above: he contributed *The Little Laundry Girl,* a five-color lithograph, and a poster for the Salon des Peintres et Graveurs to Vollard's first *Album d'estampes originales,* which also included works by Edvard Munch, Odilon Redon, Maurice Denis, Edouard Vuillard, and Félix Vallotton. Left: detail from the lithograph *Woman with an Umbrella.*

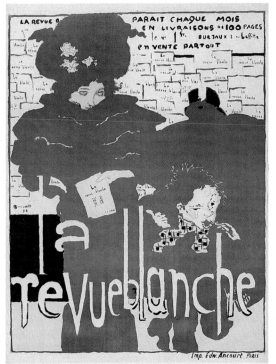

L eft: in 1894, after Thadée Natanson and his brothers (and publishing partners) Alfred and Alexandre had seen Bonnard's work at the Salon des Indépendants and Le Barc de Boutteville's gallery, they asked him to make a poster advertising *La Revue blanche.* The result is a marvel of innovation, in which the figures and letterforms are intertwined and the artist plays with white and black space. The elongated letters of the title rise up in broken vertical lines that create an almost musical rhythm with the flat black of the silhouetted figures.

B elow: *The Boulevard* is one of several color lithographs Bonnard created for a suite titled *Some Aspects of Parisian Life,* published by Ambroise Vollard.

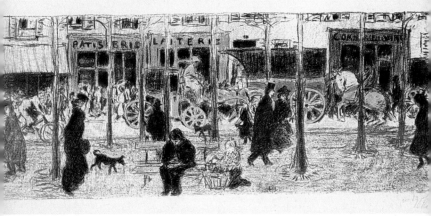

side; in this way you discover many things" about color.

In January 1896 Bonnard had his first solo exhibition at the Galerie Durand-Ruel; in it he displayed fifty-six works—not only paintings, but also his posters for France-Champagne and *La Revue blanche,* two screens (*Promenade of Nurses* and another), two lithographs, and the printed edition of *Solfeggio.*

Bonnard, Vuillard, and their comrades

Bonnard and Vuillard worked well together. As a

whole, the Nabi group also worked very collaboratively, making drawings, lithographs, and woodcuts for *La Revue blanche* and theater projects of all sorts. They made sets, costumes, and programs for André Antoine's Théâtre Libre, Paul Fort's Théâtre d'Art, and the Maison de l'Oeuvre, where Lugné-Poë produced Maurice Maeterlinck's 1892 *Pelleas and Melisande,* as well as works by Henrik Ibsen (1828–1906) and August Strindberg (1849–1912). Bonnard designed the theater posters and Vuillard did most of the programs. In December 1896 they collaborated on the groundbreaking

Below: this sketch of a meeting at the little Théâtre des Pantins records the theatrical and literary life of Bonnard and his friends. Scenery by Vuillard and Bonnard

is in the background. Claude Terrasse, with beard and full head of hair, is deep in conversation with Alfred Jarry, dressed like a cyclist, and their colleague Franc-Nohain. Bonnard is seated at right, making marionettes. Right: an illustration for La Maison de l'Oeuvre, the theater founded by Lugné-Poë, Vuillard, and Camille Mauclai (1872–1945). Lugné-Poë is portrayed in the pose of a worker.

ALMANACH
du
Père Ubu

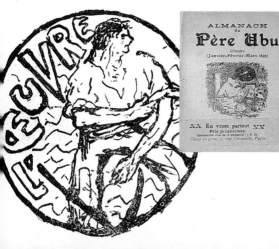

absurdist play *Ubu roi* (*King Ubu*), by Alfred Jarry (1873–1907), with Claude Terrasse composing the music and Sérusier and Bonnard creating the sets. Bonnard also made masks and marionettes for the Théâtre des Pantins, an experimental theater, or "theatricule," created by Franc-Nohain, Alfred Jarry, and Claude Terrasse, with performances in Terrasse's apartment on rue Ballu. Some of the Nabis also designed furniture for Samuel Bing's Galerie de l'Art Nouveau and glasswares for the American glass artist Louis Comfort Tiffany (1848–1933). This intense and varied activity gave the group access to all the intellectual milieus of Paris.

ALMANACH
du
Père Ubu
illustré
(Janvier-Février-Mars 1899)

✗✗ En vente partout ✗✗
Prix 50 centimes.
Abonnement d'un an (4 numéros) : 1 fr. 50.
Vente en gros, 5, rue Cassette, Paris

Above: Bonnard's drawing of Father Ubu, from Alfred Jarry's *Almanach du Père Ubu,* which was published as a periodical. Ubu, depicted as an "agronomic citidzen," or agricultural city-dweller, tests the weather. Jarry's writing is famous for puns and wordplay. Left: the cover of the issue for winter 1899.

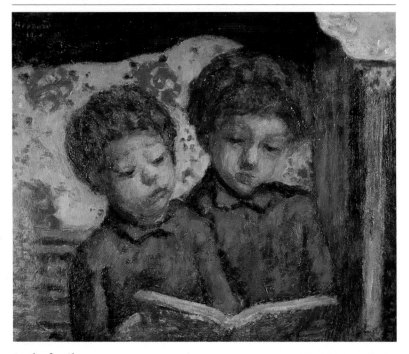

In the family

The Bonnard family continued to gather at Le Grand-Lemps each summer and fall. Life there was enlivened by the children of Claude and Andrée Terrasse. Bonnard endlessly drew and painted his nephews and nieces, Charles, Jean, Robert, Renée, and Vivette. These children, he said, "give comfort to those who do not themselves have children." Every year he returned to the Dauphiné to watch them ride the donkey, play running games with a hoop, and bathe in a pool. He would then retire to the studio that his mother had fitted up for him on the third floor of the house and work these subjects into his paintings. Once the vacation ended, he returned to Paris with its duties, music, and lamplit evenings.

Bonnard liked the softness of these winter interiors, when the doors were shut tight and the fire was burning.

Perhaps young Charles and Jean Terrasse, the boys portrayed in *Children Reading,* were about to sing, as often they did. The lamp at right establishes a lighting effect, as well as a contrast with the somber tone of the blue and ocher colors. Bonnard often created contrasting harmonies in his paintings.

Homes were still lit with oil lamps then, whose shades caught and diffused the light. So it was that he painted portraits set in a half-lit, shadowy evening, with faces that sink gently into the silence of the night. These figures inhabit a closed, secure world, whose encircling embrace holds within it both time and space.

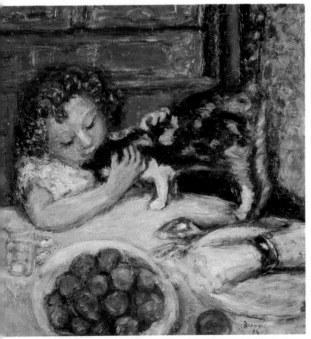

Two photographs taken by the painter around 1898, *Renée Terrasse Playing with the Dog* and *Children in the Pool.* These are from a group of pictures of his nieces and nephews playing games. Left: *Little Girl with a Cat* shows Renée at age 5, in 1899. Here again we see the tilted table, with its view of food and dishes, as used in *The Checkered Blouse.* In this scene, however, the dominant quality is the sense of harmony between the child and her pet.

Nudes: sensuality and solitude

Bonnard is renowned for his paintings of nudes. In the first canvases Marthe seems rather timid. She is usually depicted either in the bath or stepping out of it. But the artist gains confidence with his bold 1899 painting *Indolence* (originally titled *Farniente*). Everything in this work evokes sensual delight: the woman's body burns with strident, tawny, *fauve* colors and lies abandoned to the light. But at this time some of Bonnard's works also take on a new solemnity. *Man and Woman* expresses that poignant solitude born in the aftermath of pleasure. A young woman sits naked on a bed, gazing downward;

Bonnard exhibited this painting in 1899 with the title *Farniente (Idleness)*. Thadée Natanson, who bought it, retitled it *Indolence*. It is one of the painter's most directly sensual images, disturbing and unquiet, despite the lassitude of the figure.

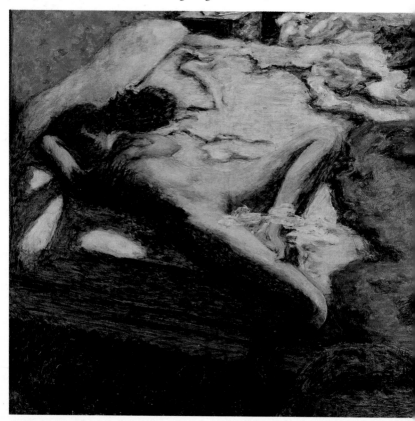

equally nude, and elongated as an El Greco figure, a man stands nearby, glancing away. Separated by the folded screen that divides the canvas vertically down the middle, each pursues a private, internal dream.

Bonnard shows us people in bondage to the human condition, defined by immutable, eternal characteristics. He began to acquire a new consciousness of himself, of time, and of the stages of life.

Master of light

The Nabi group had exhibitions in 1897 and 1898 at the gallery of the influential dealer Ambroise Vollard, and another at the Galerie Durand-Ruel in March 1899. Also included there were works by Emile Bernard, Paul Signac (1863–1935), Henri-Edmond Cross (1856–1910), and Théo van Rysselberghe (1862–1926). Thadée Natanson, writing about Bonnard's work later, called attention to his new approach to light: "With absolute mastery, he absorbs all the ambient light. At will he rarefies it, reducing it to the most exquisitely delicate minimum in *Dusk* (the original title of *The Croquet Game*) or that prodigious, silent work *Interior*. At will he floods a *Normandy Landscape* with radiant light, shining and golden, or lets it play across the superb body of a woman who lies in abandon on the bed sheets." Camille Pissarro, who had initially been rather strongly critical of Bonnard, said to his son Lucien, "This young painter will go far, for he has the eye of a painter."

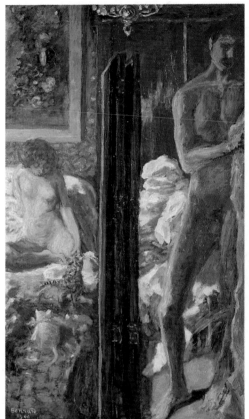

Man and Woman was painted the year after *Indolence*. Both works are dramatic and rhetorical, using sharp contrasts of light and shadow to underscore their emotional atmosphere. This canvas was bought by Thadée Natanson, who admired its seriousness and gravity.

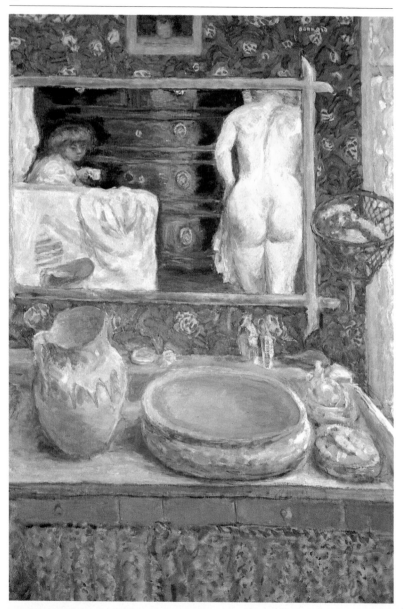

"One day, the words and theories that were the foundation of our conversations—color, harmony, the relation between line and tone, balance—lost their abstract significance and became very concrete. I had understood what I was seeking and how I would try to obtain it."

Pierre Bonnard

CHAPTER 2
"ART IS ALL IN THE COMPOSITION"

Left: although he revered the Impressionists, Bonnard used innovative compositions that were far removed from their style. The mirror was a favorite device: sometimes it enclosed an entire room within its frame, as here, in *The Bathroom Mirror,* exhibited in 1908 at the Salon d'Automne. In other paintings it expanded an interior space to include exteriors glimpsed in the reflection of an open window or door. Right: Bonnard in his studio, c. 1905.

From 1900 on, Bonnard left Paris every spring. That year he rented a small house with a garden in Montval, not far from the city, in the Ile-de-France region. His friends were nearby: Maurice Denis in Saint-Germain-en-Laye, Ker-Xavier Roussel in L'Etang-la-Ville, and the sculptor Aristide Maillol in Marly-le-Roi. Year by year he chose villages farther out of town—Médan, then Villennes, then Vernouillet—following the course of the Seine as it grew broader, opening ever vaster horizons before him. His paintings took on greater scope and a lighter tone and his palette grew brighter. He used the white, lilac, and pink of blossoming trees to complement the first greens of nature.

At the turn of the century, he was entering a period of transition. He threw himself into new projects; chief among these were illustrations for several limited-edition books. These artist's books were remarkably inventive; they in turn influenced his painting.

The first was *Marie,* a novel by the Danish author Peter Nansen (1861–1918) that appeared in *La Revue blanche* in May and June 1897, accompanied by eighteen brush drawings by Bonnard. Ambroise Vollard then asked him to make a set of lithographs for *Parallèlement* (*In Parallel*), a volume of free verse by the poet Paul Verlaine (1844–96). Vollard had wanted to pair Verlaine with Bonnard ever since

Left and below: Verlaine's volume of poems, *Parallèlement,* with illustrations by Bonnard, is today considered one of the most beautiful of all printed books as well as one of the first such modern collaborations between an artist and author. Yet it was not a success for many years. Bonnard admired the publisher, Ambroise Vollard, for his courage and foresight. The design, supple and voluptuous, intermingles verses with images and allows the drawings to overflow freely into the margins. "I produced the lithographs in pink in order to render Verlaine's poetic atmosphere," the painter explained. In the lithograph below, the motif of the painting *Indolence* is reprised.

Left: two illustrated pages from *Daphnis and Chloë*. The book of 156 lithographs was published on October 31, 1902. To evoke the rustic countryside of the tale, Bonnard drew upon his memories of the Dauphiné and the Ile-de-France. All of his compositions convey an air of subtlety and ease. "I worked fast, with joy," Bonnard recalled. "I conjured up the shepherd of Lesbos on each page with a kind of happy fever that carried me away in spite of myself."

Bonnard admired the sculptures of his contemporaries. He bought a drawing from Auguste Rodin (1840–1917) and followed the work of the Nabi sculptor Georges Lacombe (1868–1916) with great interest, as well as that of Aristide Maillol (1868–1944), whose statuettes can be seen reproduced in several of his paintings. Left: a plaster sculpture by Bonnard, *Young Woman, Standing,* c. 1907.

seeing *Indolence* at the Nabi exhibition at Durand-Ruel. The edition appeared in September 1900, illustrated with 109 lithographs printed in a deep pink ink. It did not sell well; nevertheless, Vollard immediately commissioned another book project: illustrations for an edition of the late-Roman pastoral tale *Daphnis and Chloë,* which appeared in 1902.

Sculpture, photography

By 1900, Bonnard had been working with the Nabi group for more than ten years, and they all began to feel the need for greater independence in many ways. At this time he briefly tried making sculpture, along with the painting and printmaking that already occupied him. Although he did not pursue it long, he always loved statues. Pinned on his studio walls were reproductions of antique and Renaissance sculptures, and many of his canvases reflect this taste for statuary, especially in the treatment of the nude standing figure.

And he was captivated by photography. Impassioned by

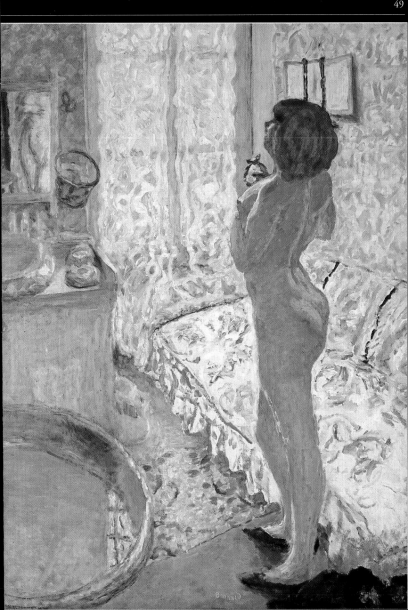

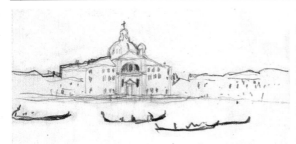

L eft: in 1899 Bonnard visited Venice with Vuillard and Roussel and made this small drawing of the church of the Redentore. He used sketches from his trips as the basis for several paintings and the illustrations for *La 628-E8*, a 1908 book by the critic and novelist Octave Mirbeau (1848–1917) that describes a journey to Belgium and the Netherlands. Its title was taken from Mirbeau's license-plate number. Below: the cover of *La 628-E8* and a drawing from it.

the immediacy of vision and avid to capture the most fleeting of images, how could he not be tempted by that new art form? What other medium so enabled one to capture the evanescent moment? Nevertheless, he never attached any artistic value to the photographs he took. Their interest for us lies in their relationship to his paintings and prints of the same period. Indeed, we find that the eye of the photographer is not so different from that of the painter, when the painter is already "photographically" inclined, cherishing the unusual, the fugitive, the unexpected. The art of the instant is the art of surprise.

At the end of the 19th century and the beginning of the 20th, Bonnard took several trips abroad. He visited Venice and Milan in 1899 with Roussel and Vuillard; in 1901 he went to Spain with Vuillard and the Romanian princes Emmanuel and Antoine Bibesco (friends of Marcel Proust), visiting Seville, Granada, Toledo, and Madrid. In 1905 and 1906 he traveled to Belgium and Holland aboard the yacht of Misia, who had divorced Thadée Natanson and was now the wife of Alfred Edwards, owner of the influential newspaper *Le Matin*. Also traveling with them were the composer Maurice Ravel (1875–1937), the painter Pierre Laprade (1875–1931), and Paul Leclercq, one of the founders of *La Revue blanche*. Bonnard retained clear, detailed memories of these excursions all his life.

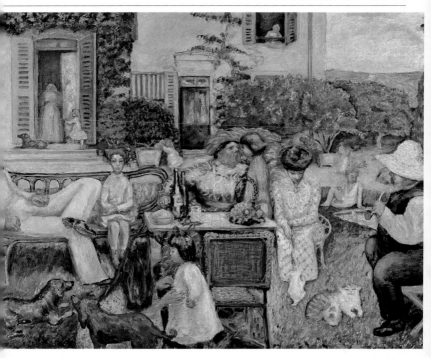

A time of uncertainty

Although he enjoyed a change of scene, Bonnard could never remain long away from Paris, with its invigorating street life and its stimulus to new ideas. He regularly exhibited at the Salon des Indépendants and in 1903 took part in the first Salon d'Automne, where he showed *The Bourgeois Afternoon,* an affectionate, slightly ironic portrait of the Terrasse family. That year he also created two posters for the newspaper *Le Figaro* and almost seventy ink drawings to illustrate *Histoires naturelles* (*Natural Histories*) by the humanist Jules Renard (1864–1910).

After so many successes, Bonnard now seemed to be once again at a turning point in his work. He continued to paint the intimate, richly patterned interior scenes for which he and Vuillard were both well known by now, and which are called Intimist. He expanded his views of Paris, exhibiting them together with small seascapes painted in

The Bourgeois Afternoon depicts the Terrasse family gathered after a meal in the garden of Le Clos, their house at Le Grand-Lemps. Bonnard illustrates the serenity of a summer Sunday with both charm and a certain caustic wit. The opulent lady at center and gentleman at right are Auguste Prudhomme and his wife, godfather and godmother to one of the Terrasse children. Prudhomme was a well-known historian from Grenoble.

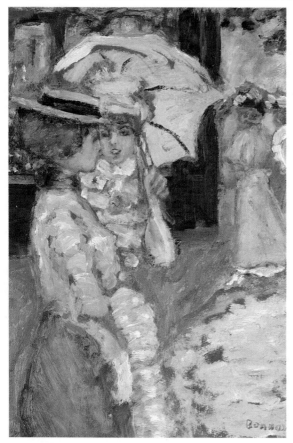

Women, depicted in passing, unaware of any observer, occupy the foreground of many of Bonnard's Paris scenes. One may fleetingly touch her hair; another grasps her long skirt in one hand as she walks. Left: in *The Promenade,* two friends stroll in the sun. The first is viewed in profile, the other full-face under her umbrella— an obligatory fashion accessory of the time, which Bonnard uses as a charming decorative element. In the background, two more ladies cross from the opposite direction. Here is a street filled with motion and bright colors—the pink and blue of dresses and shadows, sometimes modulating to mauve, punctuated by white.

Colleville and Varengeville, landscapes painted on site, and nudes done in the studio with models. This was an uncertain period, although he never lost his creative spirit. The writer André Gide called his canvases "bizarrely new and exciting"; Bonnard, he thought, was an "uneven" artist, but "inquisitive, inventive, never dreary."

Dialogue with Matisse

If the Impressionists had caused a stir with their lush colors, the artists who came along next were even more disturbing to traditionalists. A leader of this new group

Right: another view of the city in motion can be seen in *The Pont des Arts.* The Ile de la Cité is in the background. The perspective is deep, carrying the eye toward a distant horizon. The handsome woman in a large flowered hat is Misia.

was Henri Matisse (1869–1954), just two years younger than Bonnard. Others included André Derain (1880–1954) and Maurice de Vlaminck (1876–1958). Paul Signac, slightly older, painted in the summers in the French resort town of Saint-Tropez, and developed a style, called Divisionism, that used bright, discrete patches of color, similar to the Pointillism of Georges Seurat (1859–91). Matisse, also painting in Saint-Tropez in 1904, was influenced by Signac: that year he painted the famous Divisionism-inspired canvas *Luxe, calme, et volupté* (*Luxury, Calm, and Sensual Pleasure*). He met Derain in the village of Collioure the following year, and both became even more thrilled by pure color. Matisse painted a remarkable portrait of his wife, *Woman with the Hat,* which used dramatically nonnatural colors. He showed it at the Salon d'Automne in 1905, alongside Derain's brightly colored canvases. They created a sensation, and hostile critics named them "Fauves," or savage beasts.

Above: Misia's celebrated profile, done in pencil, from one of the painter's notebooks. He drew her many times over the course of his working life.

Matisse and Bonnard had known one another since the turn of the century, but it was in this year that they began

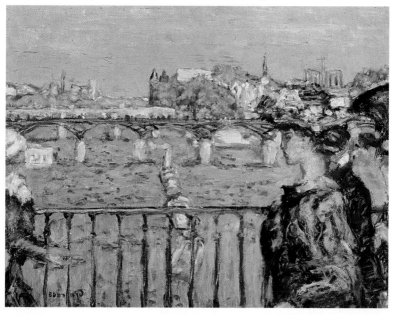

a lifelong friendship. But Bonnard, the consummate colorist, made no diversion into Divisionism or Pointillism—not even a brief visit, like Matisse's. He saw swiftly and judged swiftly, but took his time assimilating new techniques. This one, it seemed to him, was a scientific form of Impressionism; would it not lead to a rigid system and then to a dead end? "The instinct that compensates for science," he said, "may at times be superior to the science that compensates for instinct." He followed his own prodigious instinct.

Above: the chateau of Fontainebleau, with the fountain of Romulus at center. During a visit in 1907, Vuillard and Bonnard were especially interested in the great Renaissance frescoes to be found within the palace.

At the 1906 Salon des Indépendants, Matisse exhibited the huge canvas *Le Bonheur de Vivre* (*The Joy of Life*), a scene of vaguely mythological figures in a sensuous, vividly colored landscape. The critic Pierre Schneider described it as comprising "a double tradition, the pastoral and the bacchanal." Bonnard's own paintings at this time were also replete with fauns and nymphs—still under the sway of his illustrations for *Daphnis and Chloë*.

Between Bonnard and Matisse there were no harsh confrontations or clashes of theory (as Matisse later had with Pablo Picasso). The two always respected one another's work. Throughout their lives, they conducted a clear, honest dialogue, founded upon a shared understanding of painting. There was doubtless something cerebral in their conception of art, but it was inseparable

from a mutual and unswerving commitment to nature. They exhibited side by side at the Galerie Bernheim-Jeune in Paris. Bonnard had a verbal contract with the gallery from 1906 on; Matisse signed a formal contract in 1909. It was from Bernheim-Jeune that in 1911 Matisse bought Bonnard's *Soirée in the Salon;* in 1912 Bonnard bought Matisse's *Open Window, Collioure.* Neither man ever parted with these treasured images. The friends knew how much they differed from one another, and analyzed each other's work with the greatest attention and care.

Bonnard and Vuillard: an indestructible friendship

Bonnard and Vuillard were soul friends. They possessed the same discretion, the same simplicity, the same dislike of categorical assertions about art. Their greatest difference was in temperament: Vuillard was by nature solemn; Bonnard had a cheerful disposition. They often went to museums and exhibitions together, and sometimes hung paintings using the same motif side by side. One fine day in June 1907, they went to the royal chateau of

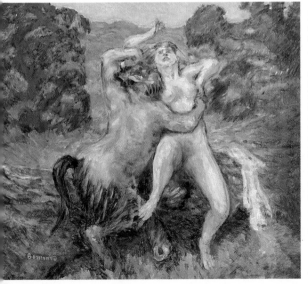

Found among Bonnard's papers was a postcard of the Primaticcio frescoes in the bedroom of the Duchess of Etampes (a favorite of Francis I) in the chateau of Fontainebleau. Above: an oval scene over a door depicts *Apelles Painting Alexander's Mistress Campaspe.* Left: in *Pan and the Nymph,* a painting based on this scene, Bonnard removed the figure of Apelles and replaced that of Alexander with a faun. The Campaspe he embraces has Marthe's body. Far left: the beautiful preparatory pencil drawing for the painting. Bonnard was fond of classical scenes. In 1902 he illustrated the pastoral tale from antiquity *Daphnis and Chloë;* in 1906 he sculpted a large *Centerpiece* of fauns and nymphs.

Fontainebleau, not far outside of Paris. Each made a pretty sketch of the palace, viewed from its celebrated parterre gardens.

That year, working in Bonnard's studio, they each made a large portrait of Marthe with her dog, Black. Vuillard's is the sole image of Marthe made by an artist other than Bonnard, and remains a testament to the friendship that bound them.

Another conception of invention

In 1907, Bonnard was 40. At this time a group of younger artists, 25 or 30 years old, were beginning to talk among themselves in their Paris studios. In particular, Pablo Picasso (1881–1973) and Georges Braque (1882–1963) commenced their great dialogue and a new chapter—Cubism—opened in the history of painting.

The previous year, Picasso had embarked upon his

Bonnard was fascinated by mirrors. Below: a mirror is the central motif of the 1909 painting *Reflection (The Tub)*. Nearly the whole canvas is taken up by this inverted scene, which is completely transformed by its distorted viewpoint, light, and altered proportions. "Bonnard cherished the accidental," said Edgar Degas.

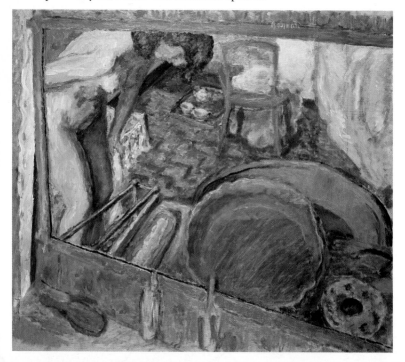

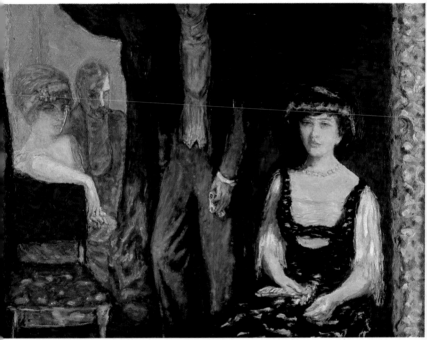

Demoiselles d'Avignon, a painting that still possesses the power to shock. Bonnard, always current with every new trend, and always resisting it, exhibited a series of new canvases, including *The Box, Reflection* (*The Tub*), and *The Bathroom.* This last was something of an homage to Impressionism, especially to Renoir, who had treated the same subject. If Renoir had once been viewed as a rebel, he was hardly so now. Thus, one might call these paintings of Bonnard's anachronistic, but only at first glance, for they use strikingly innovative compositions. "The power of invention," Bonnard said, "resides in the composition and the sense of proportions. Art is all in the composition; it is the key to everything." Two of these works are organized around a mirror—a painting within the painting. The mirror multiplies effects, inverts images, alters proportions, and reflects light. In the course of his career, Bonnard returned more than once to this conceit, giving it a primary role. The mirror itself was often the subject of

The Box was another homage to Renoir, who often painted theater scenes. The sitters are the brothers Josse and Gaston Bernheim, owners of Bonnard's gallery, and their wives in their box at the Paris Opera. The face of one figure is cut off halfway by the edge of the canvas; the unusual cropping and intense palette of the picture— all deep reds and vivid vermilions—surprised the painter's contemporaries.

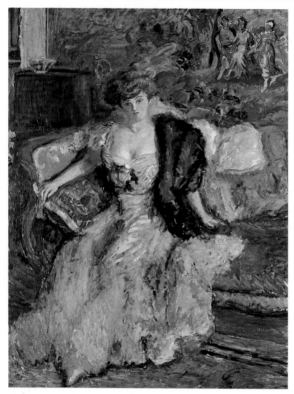

Opposite above: one of the decorative plates designed by the artist for Ambroise Vollard. It was fired by the ceramist Méthey.

Left: like *The Box,* this sumptuous *Portrait of Misia* dates to 1908. Bonnard made several portraits of this intriguing young woman, who attracted all the artists of her time. Here, he has painted her in her apartment on the quai Voltaire, seated before one of the large panels he had created for her sitting room. Opposite below: the panel called *The Voyage.* The writer Léon-Paul Fargue described the panels as a "large dense garden, green and golden."

"You know that November harmony in which the black trunks of the chestnut trees chime with the russet gold of the leaves," wrote the critic Henry Bidou, in *La Gazette des Beaux-Arts* in 1910. "Monsieur Bonnard has enclosed his panels in a band of that yellow tone—not as a single uninterrupted border, but broken up into a thousand dots, angles, hooks, spurs, and curves. He has made a frame of black dots and within it has drawn all sorts of animals."

the painting, occupying virtually the whole of the picture plane. For the viewer, this created a feeling of distance and emphasized the artifice of painting.

Bonnard the decorator

Amid all this feverish productivity, decorative-arts projects served as a rest and diversion. In 1910, Misia (who had by now divorced Edwards) commissioned Bonnard to create four large panels for the sitting room of her apartment.

The subjects were *Pleasure, Study, The Game,* and *The Voyage* (later renamed *Jeux d'eau,* or *Fountains*), themes upon which he invented a thousand extravagant variations: fauns, nymphs, women bathing, children playing in pools. Figures dance in gardens with flowing

fountains and along riverbanks, or stroll through hazy forests where deer roam. At times, the colors are finely shaded to coordinate with the draperies and antique furniture in the apartment. To unify the set, each panel was given a painted false frame done in matching tones of orange, yellow, and green, with similar motifs. But where is studious contemplation to be found amongst all these lively caprices? All is pleasure and games; Bonnard wanted only to delight his friend.

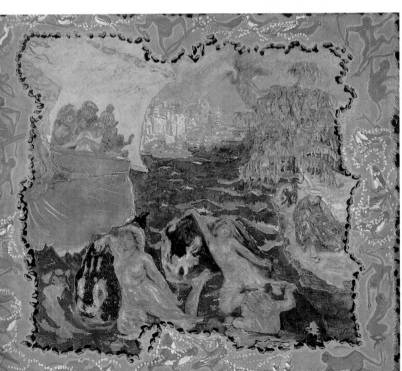

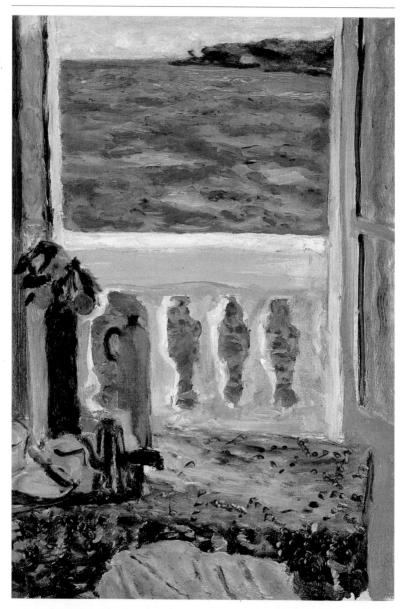

In 1909 Bonnard followed other painters—Signac, Matisse, Henri Manguin, and Albert Marquet—and spent his first summer at Saint-Tropez, in the region called the Midi, in the south of France. It was, he said, "a taste of *The Thousand and One Nights:* the sea, the walls, the yellows, the colored light and its reflections…!"

CHAPTER 3
"COLOR SEDUCED ME"

Left: *Window Open on the Sea* was painted during a visit to Antibes in 1918–19. The broad blue band of the Mediterranean pours through the balcony railing and the open window to strike the eye. Right: *View of a Port in the Midi,* a pencil drawing.

When Paul Signac and the Fauves discovered the Midi towns of Saint-Tropez and Collioure in the first years of the century, the impact on their work was immediately visible. It affected Bonnard a little more slowly. He was dazzled by the brilliant landscape and colors of the south and gradually translated them into paintings. A 1912 Midi landscape called *L'Allée* (*The Path*), or *View of Saint-Tropez,* captures the intense luminosity of the Mediterranean coast; it is a study in yellows with the contrasting blue ribbon of the sea in the distance. He later reworked the same scene as the central panel of a huge triptych commissioned by a Russian collector named Ivan Morosov, who had bought two other works by him, *The Bathroom Mirror* and *The Train and the Barges.* This triptych, entitled *The Mediterranean,* was shown in 1912. He returned to Saint-Tropez in September 1910 and spent the summer of 1911 there with Signac,

Above: Bonnard in the garden of Villa Antoinette in Grasse in the summer of 1912.

painting views of the port and the narrow, sunny streets.

He spent the summer of 1912 at Grasse, another Mediterranean town, at the rented Villa Antoinette. There he painted a canvas called *Summer,* which became the central panel in a second vast triptych for Morosov. The wing panels were called *Spring* and *Autumn;* the former was painted in the Normandy village of Vernonnet, on the Seine, close to Claude Monet's home at Giverny. Bonnard had bought a country house near there, at Vernon, which he kept until 1938. *Autumn* was painted at Le Grand-Lemps, and depicts the grape harvest there. These three landscapes—the Midi, Normandy, and his native Dauphiné—together comprised his universe.

Hand-to-hand with color

The discovery of the Midi marks an important moment in Bonnard's oeuvre. The paintings of the 1910s reveal his overwhelming passion for color, which becomes the primary feature of his art. But the canvases of these years, when examined closely, also express a certain anxiety. This impression of stress is most discernible when these paintings are compared with the earlier, more serene works, such as *The Bathroom, The Bathroom Mirror,* and the large decorative canvases. It becomes that much stronger again in light of some new and powerful works, like *The Red Checked Tablecloth* and *Summer in Normandy,* that suddenly appeared among a number of paintings of lesser importance and seem to refute this impression.

The composition of *The Red Checked Tablecloth* shows the complexity of Bonnard's genius and his sharp attention to detail. The canvas is divided into two zones: in the upper register are Marthe and the dog Black. The

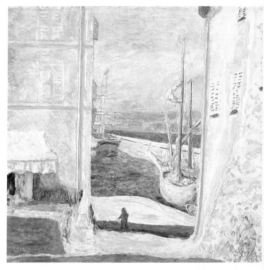

View of the Port of Saint-Tropez, exhibited at Galerie Bernheim-Jeune in June 1912, perfectly illustrates the painter's enthusiastic memories of the Midi:

"The sea, the walls, the yellows, the colored light and its reflections…!"

Left: the triptych *The Mediterranean* repeats *L'Allée (View of Saint-Tropez)* in its central panel. The art historian Henri Focillon called these paintings "luminous Mediterranean fairy tales."

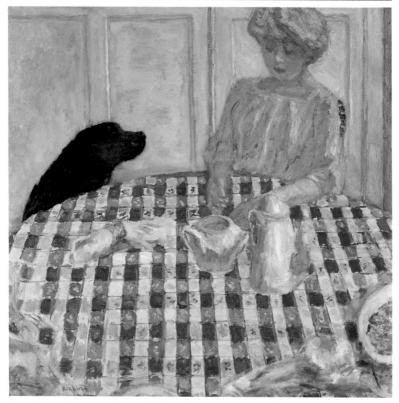

lower half of the painting is filled with the flat plane of the checked tablecloth. The edge of the circular table marks the division; its curve is repeated in the position of the white objects set on the cloth, revealing the artist's acute powers of observation.

Bonnard began to paint large, lush landscapes, often seen from within a room, framed by a window or open door, which emphasizes the breadth of the view over the countryside. The critic André Lhote called these "compound landscapes." An early example is *Summer in Normandy*, in which two figures at the edge of the scene, one seated in the light, the other stretched out in the shadows, echo effects of light and shade on the greenery and foliage in the garden. In the distance beyond, the

The composition of *The Red Checked Tablecloth* owes something to Cubism. The tilted tabletop inscribes an oval across the surface of the painting, filling most of the picture plane. Georges Braque used similar arrangements in paintings dating from the same period. An interesting confluence between Impressionism and modernism occurred in the year 1912.

bank of the Seine is visible, evoking delicate impressions and a faint aura of mystery.

The demands of form

It is difficult to establish a strict chronology for Bonnard's oeuvre. He favored several subjects—especially room interiors, landscapes, portraits, nudes, and still lifes—returning to each of these randomly and repeatedly, rather than in an orderly progression of series. Often he combined several of these motifs in a single work, and was especially fond of the image of a threshold between two states: interior and exterior, light and shadow. Sometimes a figure stands at the border between them. He followed his instincts in the choice of theme; sometimes a single motif inspired a new enthusiasm and he would paint several versions of it, to be compared with one another. Or he would decide that he had not pursued an idea to its conclusion.

His fascination with the dazzling Mediterranean landscape led to a new conflict in his style. How was he to capture the intensity of that unique light? The only way to express it, he felt, was through color. As he explored this way of painting, forms became less distinct, and he struggled to prevent them from dissolving entirely. "Color seduced me," he said. "Almost unconsciously, I sacrificed

Above: Bonnard designed a poster and the witty cover of the catalogue for the 1912 Salon d'Automne. A visitor, face averted, inspects the paintings while a young girl leans on her elbows, preferring to look outside.

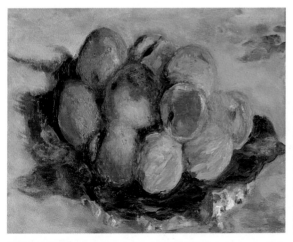

These succulent *Peaches*, painted around 1916, flaunt their velvety skin, nestled upon dark green leaves that all but conceal the white china dish beneath. The tablecloth is speckled with soft patches of pink, blue, and mauve.

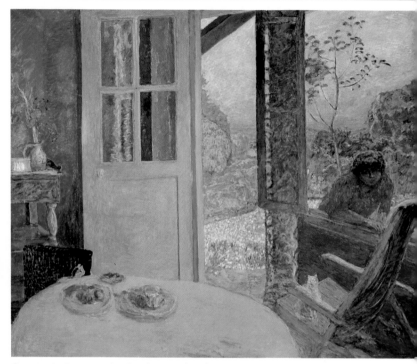

form to it. But it is absolutely true that form exists, and one cannot deflect it arbitrarily or indefinitely."

As his style developed, he began to work more on composition and draftsmanship. He would first make a quick sketch of the idea for a painting, using hard pencil or pen. He then made a set of studies of each element: faces, trees, and objects, one by one. For some paintings

A bove: *The Dining Room in the Country;* below: two of the many precise preparatory drawings he made for the painting.

it is possible to assemble these preparatory drawings, so as to reconstruct the genesis and progression of the final work. Such is the case with the superb *The Dining Room in the Country,* painted in 1913. A door and window open onto a garden, framing an iridescent landscape, coruscating with bright colors. The strong vertical and horizontal lines are balanced by the sweeping curve of the table. The room within is painted in hot, intense tones and luminous pastels; a lace curtain that hangs vertically down the center of the canvas, dividing door from window, gathers together all the mingled colors.

Eclectic tastes

Although he spent a great deal of time in Normandy and the Midi, Bonnard also remained fond of Paris. Montmartre was his neighborhood of choice: he had a studio at 65 rue de Douai and another, later, at 22 rue Tourlaque. He lived around the corner at 49 rue Lepic. Between 1912 and 1916 he rented a house in Saint-Germain-en-Laye, but Paris had the museums and galleries, where he exhibited his work and saw the paintings of other artists.

Below: Bonnard made the large 1912 painting *Place Clichy* for Georges Besson's Paris apartment. The square is seen from within the Wepler brasserie, as if it were a small theater and its yellow awning a proscenium curtain. Building facades form the backdrop; the sidewalks bustle with pedestrians and a yellow car crosses through broad daylight. In the middle of the scene, the lightstruck figures of two girls turn to face the "audience," their hair shining like haloes. All is motion and energy in a flood of sunshine.

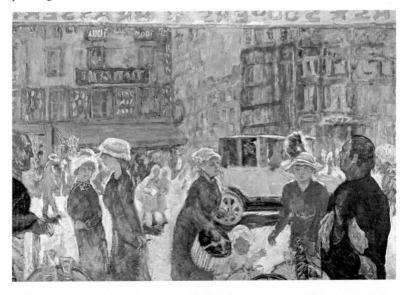

What continued to draw him to the city,
above all, was a profound sense of the layers of
experience among its artists. He was interested
in many of the trends and styles he saw there,
and was never dogmatic or exclusionary in his
tastes. He liked Cubism for its clarity and
order, and the darkly Fauve paintings of
Georges Rouault (1871–1958). He attended
Rouault's first solo exhibition at the Druet
gallery in 1910. "Bonnard," Rouault later
recalled, " was not overly enthusiastic about
my ceramics, but focused on my paintings.
I now see that he was right."

He owned a modest collection of paintings
and drawings by his contemporaries and his
choices were revealing. He had works by the
Nabis Sérusier, Vallotton, Roussel, and
Vuillard, and by two friends of Signac,
Henri-Edmond Cross and Maximilien Luce
(1858–1941). He hung Matisse's great *Open Window,
Collioure* next to Cézanne's *Bather with Outstretched
Arms,* which he had gotten from Vollard in exchange for
one of his own canvases. He had a small nude by Renoir;
a drawing in conte crayon by Seurat called *Hat and
Umbrella* that was a study for *The Posers.* He bought a
watercolor from Rodin called *Nude Seen from the Back*
and a pastel by Redon entitled *Flowers.* "I have
the greatest admiration for
Odilon Redon," he said.
"What strikes me most about
his work is the union of two
virtually opposing elements: pure
material substance and an expressive
sense of mystery." That same
sensibility is to be found in
Bonnard's own oeuvre.

Surrounded by this diverse
collection, he continued
down his solitary path. His
conversation with nature
deepened: he dwelt lin-
geringly on the water, the sky,

Above: *Hat and
Umbrella,* a drawing
by Seurat. Below: *Marthe
and Ubu the Dachshund,*
a sketch for *The Stream.*

and the nuances of light as the time and seasons changed. The simple titles that he gave to his landscapes reveal this preoccupation: *Rainy Landscape, The Seine in September, Gray Vernon, Mistral Sky,* and *Morning in the Midi.* Day after day he recorded closely observed details of the weather in his journal. He began to envision nature as a living entity—the world as animate, infused with spirit and life, in which human beings had their place. In his art, he embarked upon an extended dialogue with this animate world.

In 1916 the Bernheims commissioned him to make a set of four large decorative canvases, which he completed in 1920: *Mediterranean, Pastoral Symphony, The Earthly Paradise,* and *City Landscape.* The scenes are of Saint-Tropez, the countryside near his country home at Vernon, and Paris. In 1918 a Swiss art lover named Richard Bühler asked him to paint six landscapes; these were executed at Uriage-les-Bains, a town near Grenoble, in eastern France. In these suites Bonnard began to show an interest in large scale and grand scope. *The Large Terrace at Vernon,* painted in the same period, also uses this new element.

In the paintings of these years, Bonnard integrates Impressionist traditions with his own sense of color and free gesture. How carefully he places the subject in space; how well-judged are the forms and the play of light and shadow. In these large tableaus Bonnard mastered the difficult transition from Impressionism to his own personal idea of art.

The Stream is one of several landscapes painted at the resort town of Uriage-les-Bains. Though the canvas is filled with wild landscape, a chateau can be seen in a corner, children dance in a field, and Marthe plays with her little dog. Overleaf: in *The Large Terrace at Vernon* the human figure is almost subsumed into the exuberant foliage and bewitching blue light.

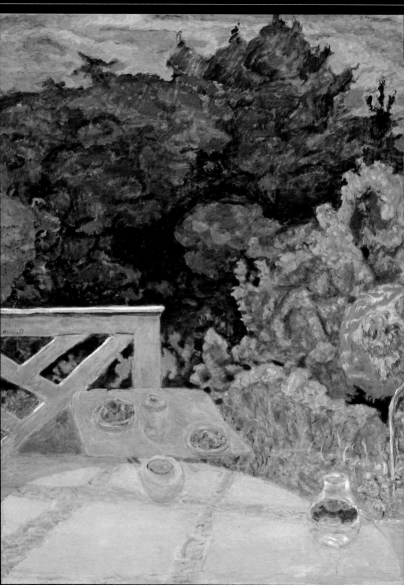

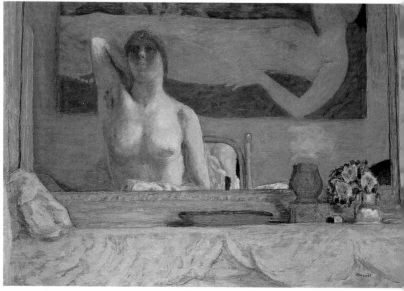

The landscape of the body

"The charm of a woman," Bonnard said, "can reveal many things to an artist about his work." Female figures predominate in his oeuvre, and he loved to depict the body in motion and at rest, though he also studied faces in depth. Young women—often Marthe—were his favorite

The Mantelpiece is another example of Bonnard's exploration of mirror images. The composition is particularly complex: the upper body of a woman is seen framed in a mirror; she poses, in a rather sculptural manner, beneath a horizontal painting of a reclining nude by Maurice Denis, also centered within the mirror frame. (The painting is one long owned by Bonnard.) The mirror does not rest on a dressing table, but hangs over a fireplace mantel. Its reflected image adds distance between the subject and observer, and magnifies the element of surprise. Left: a sketch, *Nude in the Tub.*

models. He painted them in a hat, in a turban, with a pink collar, with a seagull, blending into a landscape, clustered in an interior, walking, seated, leaning over a basket of fruit. He caught the gestures of a woman as she watched herself in a mirror, combed her hair, sponged herself in a bathtub. His many drawings of nudes bathing and dressing use a motif inherited in part from Degas and in part from an older, classical tradition of bathers; it was a source of endless invention.

Left: another study of a *Nude in the Tub.* Below: *Woman in the Tub, Blue Harmony,* 1914–16. The painting is a series of curves: the round rim of the tub echoes that of the washbowl and the curve of the woman's arched body. Her skin, touched with golden light, contrasts gently with the blues of the curtain and patterned tile floor.

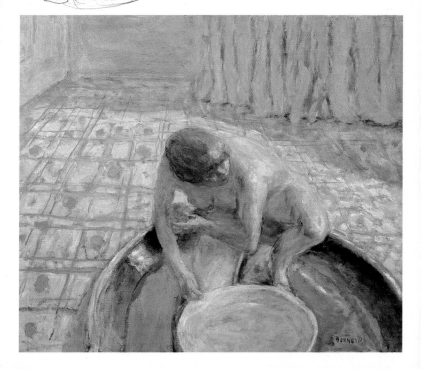

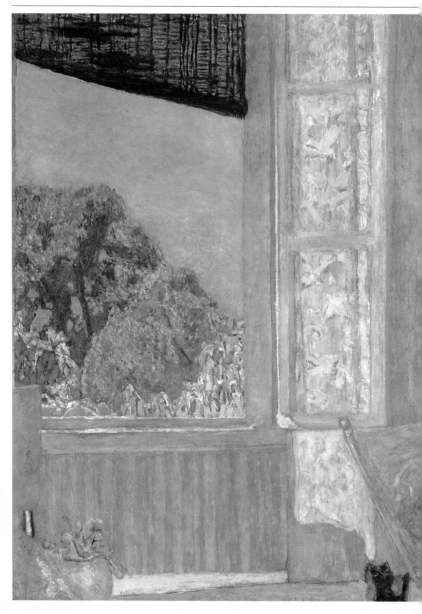

At the turn of the century, new art movements followed one another in quick succession: the Nabis around 1890; Matisse and the Fauves in 1905; Braque, Picasso, and the Cubists in 1907; and then the Surrealists. "Society was ready to welcome Cubism and Surrealism before we had reached our objective," Bonnard remarked. "We found ourselves in some sense suspended in the air."

CHAPTER 4

LYRICISM ON A NEW SCALE

Left: *The Open Window* is in the house at Vernon. The blue midsummer sky, filtering through the blind at the top of the canvas, veers toward mauve above the treetops and dances with the orange of the room. Right: one of Bonnard's many sketches for the composition, showing an earlier idea for it.

André Breton (1896–1966) published *The Surrealist Manifesto* in 1924. In the opening years of the 1920s, the Nabi painters continued to work in their established style, while around them Surrealism began to appear in painting and literature. Bonnard's art concentrated ever more on color. Confronting the influences of the external world, he maintained his independence.

A new scene

The years just after World War I were marked by a new consciousness, for the war had called into question the very idea of civilization. "We have the feeling that civilization itself possesses the same fragility as a life," wrote the poet Paul Valéry in 1919. Seeking the roots of culture and civility in this shell-shocked aftermath, many artists turned their eyes to the Mediterranean world, hoping, with a certain sense of urgency, to rediscover their ancient heritage. Paul Klee (1879–1940), Matisse, Henri Laurens (1885–1954),

Above: Bonnard met the pretty, blonde Renée Monchaty in 1918 and hired her as his model. He painted some twenty portraits of her, capturing her sensitive and dreamy nature. They became lovers, visiting Rome together in 1921. She often appears as a figure in his book illustrations too, notably in Claude Anet's 1922 *Notes sur l'amour (Notes on Love)*. But Bonnard remained with his lifelong companion, Marthe. Did Renée want a commitment he could not give? She committed suicide in the autumn of 1924. Profoundly affected, Bonnard always kept some of the works she had inspired. Left: a color-pencil drawing of the Roman countryside.

Braque, and Fernand Léger (1881–1955) all traveled to Greece or Italy; Picasso had already been there, spending part of the war in Rome.

Bonnard spent the winter of 1920 in Saint-Tropez with the painter Henri Manguin (1874–1949) and went to Rome the following March. There, he visited the museums, accompanied by his nephew Charles Terrasse, an archivist-paleographer resident at the Ecole Française in Rome, and his friend Renée Monchaty. Like many another painter, he had long been drawn to mythology and ancient art, though he had yet to paint *The Abduction of Europa.* From this trip he brought back numerous reproductions of ancient artworks and many notes and upon his return he painted a Roman scene, *The Piazza del Popolo,* in which Renée Monchaty appears at left. He also made a series of etchings to illustrate *Sainte Monique* (*Saint Monica*), a book by Ambroise Vollard.

Below: T*he Piazza del Popolo* is the only painting by Bonnard with a non-French setting, aside from some early works done in Hamburg in 1913. "The foreground figures are viewed in half-length, as if glued to the bottom edge of the canvas. The strong draftsmanship recalls paintings of fifteenth-century Italy. The woman who holds up a scale has the weight and solemnity of an ancient sculpture," wrote the art critic Sasha Newman in 1984.

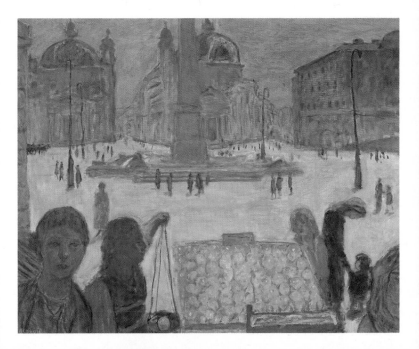

Inside meets outside

After Rome he returned to his country house at Vernon
and embarked upon a set of paintings of the windows
and doors opening onto the garden. The aim of these
new compositions was to emphasize a contrast, played
out on the surface of the canvas, between the closed
space of a room and the expansive outdoors, with each
zone firmly defined by door and window frames. The
open door or window was a subject often depicted by

"Bonnard introduced the
delights of intimacy into
the simple architecture of
painting, without
compromising his taste
for the monumental,
which is the most visible
achievement of Cubism."
André Lhote,
Bonnard: Seize peintures,
1944

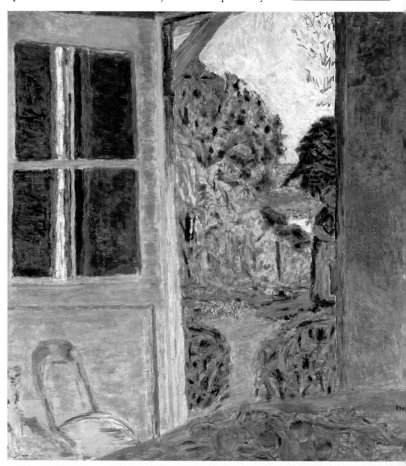

painters, including Henri Matisse. Matisse saw interior and exterior as a single unified space, and strove to render this perception precisely. "In my mind," he said, "they are one." Bonnard, however, saw interior and land-scape as discrete, maintaining the uniqueness of each in his work. Using strong compositions and a fine modulation of colors, singing in skillful harmony, he integrated the intimacy of the interior with the great airy space of the countryside.

"Color is the motive"

Art historians, observing an artist's work over his lifetime, customarily identify different periods or developments in his style. But Bonnard was remarkably consistent in his

work, and faithful to his chosen themes and subjects. Changes over time are to be seen mainly in the ever greater care with which he worked out subtle modifications in his treatment of a subject—variations of light, point of view, color. Color became more and more important and active. The Impressionists had used color with great nuance, but to an essentially descriptive end; Bonnard insisted upon color's expressive power. Color seduced him, and he in turn used it seductively. Even so, he analyzed it endlessly: color, he said, was the rationale, the motive for the work. The strange harmonies and associations of his painterly mirror-world owe as much to a relentless study of color, in the silence of the studio, as to his great visual sensitivity. "Make no mistake," remarked Gauguin in 1902. "Bonnard, Vuillard, Sérusier (to mention a few of the younger ones) were musicians; color painting had unquestionably entered a musical phase." Bonnard's work was a song of color.

Bonnard occasionally added watercolor touches to his pencil studies for paintings. Above: a stand of trees by the Seine is the central section of *The Door onto the Garden* (left).

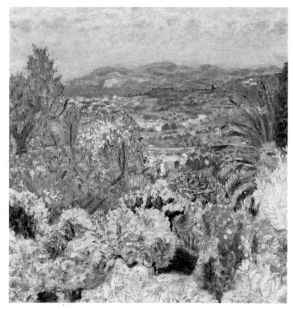

Left: like many of Bonnard's Midi landscapes, *The Côte d'Azur* embraces a broad field of vision, unframed by any doorway, window, or terrace. The scene is observed from a high viewpoint, looking over a wide expanse of countryside to the sea and the horizon. In the distance are the mountains of the Esterel region. The only framing device is the rich foliage itself—yellow highlighted with gold; greens and blues dotted with turquoise—which opens out through the middle of the canvas to reveal the deep perspective. Here, as always, color is sensuous but highly controlled: the small flecks of orange that form rooftops are underscored in violet. The sky is a symphony of variegated gradations of light. Trees are evoked with quick, luminous strokes—a new technique for the painter. Bonnard made many versions of this landscape.

An ordinary life

After World War I Bonnard stayed in Paris only intermittently. In 1916 he rented an apartment at 56 rue Molitor in the suburb of Auteuil, where his brother-in-law, Claude Terrasse, had moved with his family. But he continued to come into the capital to meet friends. He painted scenes viewed from the balcony of his building or from the Pont de Grenelle, a bridge over the Seine. In 1920 he painted the immense stage scenery for a production by the experimental Swedish Ballet. This was the legendary *Jeux* (*Games*) danced by Vaslav Nijinsky, with music by Claude Debussy, choreography by Jean Börlin, and costumes by Jeanne Lanvin.

Bonnard continued to exhibit his work in Paris at the Galerie Bernheim-Jeune, as well as the annual Salon d'Automne, but he spent much of his time with Marthe in the Midi and Normandy: winters in Cannes, Saint-Tropez, and Le Cannet; summers in Vernon, with several long stays in Arcachon. He and Marthe also visited the

resort towns of Luxeuil and Saint-
Honoré-les-Bains, in the Vosges
and Morvan regions. Usually they
rented a villa, but sometimes stayed
in the grand hotels of the era, such
as the Grand Hôtel de France in
Arcachon and the Trianon-Palace
in Versailles.

 Marthe was then in poor health
and they led a quiet life. Bonnard
did not value money very highly,
but neither did he scorn what it
could offer. He bought his first car,
a Renault, in 1912; later he had a
Ford, and then a comfortable
Lorraine-Dietrich, and he loved to
travel the countryside in them. His numerous trips did
not interrupt his work—in fact, quite the opposite. He
returned from Arcachon with *Beach at Low Tide* and
several other seascapes, and from Saint-Honoré with
Large View of Saint-Honoré-les-Bains.

 1923 was a year of great sadness. Claude Terrasse died
in June, followed three months later by his wife, Andrée,
the painter's sister. Soon thereafter he left rue Molitor
and returned to the Place Clichy neighborhood, at 48
boulevard des Batignolles.

Although *Vista over the Riverbank* is a relatively small painting, it still conveys a sense of space and distance. Its constricted composition produces a decorative effect, heightened by the richness of its colors.

"He gives the impression of having invented painting"

In April 1924 Galerie Druet mounted Bonnard's first
retrospective exhibition, comprising sixty-eight paintings
made between 1890 and 1922. "Like the rarest artists, he

Below: Marthe and Bonnard at Vernon, in a series of photographs taken in 1921 by Georges Besson.

gives the impression of having invented painting," wrote the art historian Elie Faure. "This is not merely because everything in the world—everything, every day—is new for him and so he expresses it in a new way, but also because he stands at the dawn of a new intellectual order. He was the first to organize it, following a rhythm of which we had been unaware before his arrival: the fine old harmonies that make us what we are." These are perceptive comments, far more thoughtful than the shallow opinions of those who, believing they were praising him, spoke of Bonnard as a childlike or naive painter and extolled his "ingenuous greatness."

Monet and Bonnard in the former's garden at Giverny, about 1925.

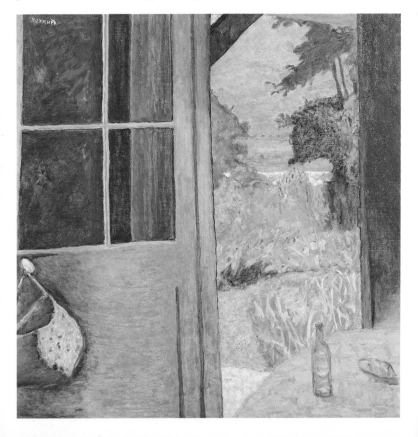

The landscapes of the 1920s are composed in a series of sharply delineated planes of shadow and light. *Normandy Landscape, Landscape at Le Cannet,* and *Balcony at Vernonnet* all use this technique; they have a sense of breadth and grandeur that derives in part from wide-angled compositions that encompass great spaces, and in part from Bonnard's forceful lyricism. His clustering treetops, bathed in light, call to mind the

Thadée Natanson recalled: "La Roulotte [the country house at Vernon] often saw the arrival of Monet's car, when he came to see Bonnard's latest works. He always studied them attentively. Bonnard spoke a little more than Monet, though neither

pastoral scenes of the great 17th-century painters Nicolas Poussin and Claude Lorrain. Color comes alive through vivid contrasts: greens, blues, and violets are flecked with orange; yellows and oranges in turn are speckled with blue and violet; the painter seems to have discovered new harmonies of light and hue, radiant under the sun.

A circle of friends

While at Vernon, Bonnard often visited his friend Monet at Giverny, as he had visited Renoir in Cagnes. Sometimes Vuillard accompanied him. "I've been to see Bonnard and Vuillard; I like what they are doing very much," noted Monet, after a visit to Vernon. Other visitors included the art dealers Ambroise Vollard and the Bernheim brothers; Bonnard continued his collaborations with Vollard, who published Octave Mirbeau's *Dingo* with fifty-five etchings by him in 1924.

Another visitor was Matisse. He and Bonnard maintained their long dialogue throughout these years, both deeply conscious of speaking as equals. Living away from Paris, they began to correspond in postcards and letters. The first extant card, dated 1925, was from Matisse, writing from Amsterdam. He sent a view of the port, inscribed "Long live painting!"

said much. But a word or a smile from the venerable Monet was enough to make Bonnard feel utterly happy." Above: "My dear Bonnard…" a letter from Monet.

Left: a version of *The Open French Window,* done in a color harmony based on a powerful red.

84

Bonnard was one of the century's great book illustrators. He worked for *La Revue blanche, Verve, Cahiers d'aujourd'hui,* and other magazines, as well as collaborating with such diverse and illustrious authors as Paul Verlaine, Octave Mirbeau, André Gide, and Alfred Jarry and some of Paris's best experimental publishers. He was skilled at working with writers, and his art was always sympathetic to their texts. Here are a few of his images and designs for pages and covers. At upper left are pages from Jarry's *Alphabet du Père Ubu.*

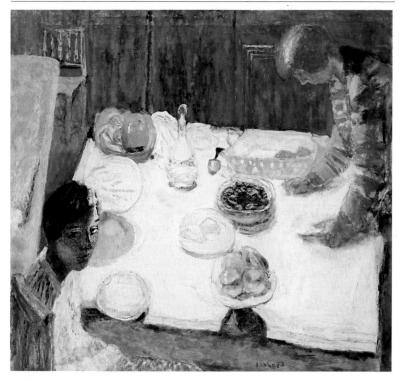

Sublunary evenings

Bonnard's method was to observe a scene or image closely and then reflect upon his observations, exploring his thoughts in multiple canvases, and continually restimulating his eye and intellect. As he created the huge, sunlit landscapes of the 1920s, he also painted contrasting scenes: large-scale interiors set in evening light. These *Evening Interiors* cannot be considered like those cozy, small-format interiors he had painted in the early Nabi years—the paintings that, along with Vuillard's, have been called Intimist. In *The White Tablecloth* and *The Table*, both from 1925, we no longer have this sense of intimacy; there are no more people reading or playing cards, no more music practice or children doing homework, no more little gatherings

The White Tablecloth (left) and *The Table* (right) both date to 1925. Both canvases depict the end of a meal, with the table ready to be cleared. The scenes are viewed from above: bottle and carafe, baskets of bread, compotier and fruit bowl, plates of cookies, a knife or a spoon are all plainly visible, as if they were actors onstage, on the point of exiting.

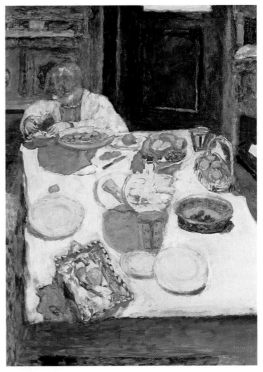

beneath warmly glowing lamps in densely patterned rooms. The simple titles indicate the direction of this new aesthetic: here are scenes of open space and solitary figures. Electric light from a barely visible hanging lamp strikes the bright planar surfaces of a tablecloth, a table, like daylight coming through the window.

These are the nightscapes of an artist sensitive to the mysterious life that emanates from simple, mundane objects, as he is sensitive to figures isolated within the silence of a habitual act as if in the secret world of a private dream.

Marthe: the model, the wife

Bonnard's landscapes and homely rooms are often populated with quiet figures, usually women. Their faces are always expressive, inscribed within the composition like the enigmatic faces of hieratic figures in medieval frescoes. Some-times these pensive gazes call to mind the sidelong glances in Giotto's pro-files. The artist's own emotions are revealed in them—they have a certain air of melancholy, even bereavement, and a solemn consciousness of

Left: Matisse's first postcard to Bonnard declares, "Long live painting!" Below: the objects in these mealtime scenes are scattered casually about the table, without hierarchy or artful arrangement. They exist to carry colors; their shapes are defined by the soft, deep shadows they cast. The circumscribed space and directed light-ing lend these tabletops a theatrical air.

the passage of time. They express a sense of ever-growing disquiet, an urgent compulsion to create while time remains.

Some of these portraits reveal an underlying psychological truth: the painter could not conceal the depression that seized Marthe during this period and made human company distressing to her. Indeed, their frequent long trips to the seaside or the mountains were her best means of relief. But was the desire for isolation and quiet Marthe's alone? Bonnard himself had long needed solitude to pursue his work, and Marthe was an astute and intelligent companion and observer. To please and thank her, he married her in 1925. She was yet to inspire some of his most beautiful canvases.

In this decade Bonnard's paintings of nudes also took on a new intensity of tone. Where his earlier paintings of the nude had been voluptuous and Intimist, rich with colors and patterns, he now explored a new goal: to paint the figure as a three-dimensional, sculptural form. In the manner of Degas, he presented each bather as the single essential compositional element of the painting. She fills the space of the canvas, depicted without sentiment, but with close attention to pose, stance, and all the nuances of feminine gesture. His mastery of color reaches its zenith in the

Many of Bonnard's paintings of women before mirrors are bust-length or half-length images, but at one time he undertook a series of vertical canvases showing a nude woman viewed from behind and standing before a mirror that reflects a front view. The body is thus displayed in its full resplendence. Left: *Nude before a Mirror.* Below: *The Bath,* a 1925 lithograph made for an album published by Frapier.

iridescent shadings and opalescent tints with which he evokes the warm variations of skin tone under light, in singing passages of paint.

"The humble psychology of things"

A radiant still life often appears at the edge of these compositions: some fruit in a basket whose handle echoes the curve of a tilted profile; or bowls and plates whose broad, round shadows soften the stiff poses of figures. Bonnard's modest personality often concealed his feelings, but in his art—even in these golden fruits, these gleaming apples, grapes, and oranges—we may see a hint of a private, sublimated sorrow or melancholy. In these simple bowls of fruit, whether details of larger scenes or painted alone, Bonnard raised to a new level the intimate dialogue of man and inanimate object— what the poet Pierre Reverdy called "the humble psychology of things."

Perhaps he had another stimulus for still lifes as well: Paul Cézanne had four exhibitions at the Galerie Bernheim-Jeune between 1920 and 1926. No painter has made more profound use of the still-life motif; Cézanne's apples and oranges focused Bonnard's attention, and he produced the strong composition of the *The Compotier* and *Bowl and Plates of Fruit,* with their

Nude Dressing presents another aspect of the nude. The model, shown from the back, is caught in a natural pose, in the act of stepping into her petticoat. The resonance of the figure is heightened by the splendid, opalescent light that bathes her form and brightens the white fabric.

deep blue shadows. And his fruit always retained its perfume and savor.

He never lost the private sense of joy that he felt when he looked at beautiful, natural things. In his journal he recorded the words of the philosopher Blaise Pascal: "What a vanity is a painting, which attracts our admiration by its resemblance to things that we do not admire in the original!" To which he added, "But on the contrary, they delight us!"

Above: a meticulous pencil study for *The Compotier;* below: *Bowl and Plates of Fruit.*

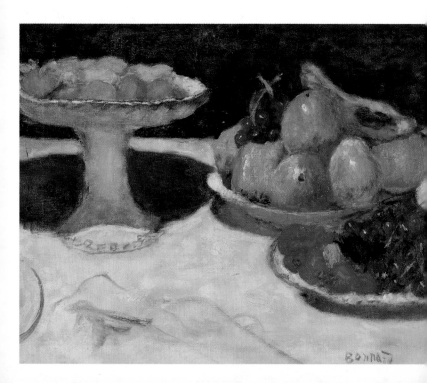

Meeting the American public

In 1926 Bonnard was invited to sit on the jury for the Carnegie International Exhibition in Pittsburgh, Pennsylvania. Afterward he traveled around the United States, visiting Philadelphia, Chicago, New York, and Washington, D.C., where he met the collectors Marjorie and Duncan Phillips, who were already interested in his work. He took the opportunity to rework a painting they owned, *Early Spring,* painted in 1909. He altered some of the colors and, in his enthusiasm, signed it a second time.

In April 1928 the de Hauke Gallery in New York organized Bonnard's first solo exhibition outside of France. A wide range of his works was included, from his earliest interiors to the recent large landscapes. Several paintings were loaned by their owners, including *The Côte d'Azur,* of 1923, and *The Palm,* of 1926, both later purchased by Duncan Phillips.

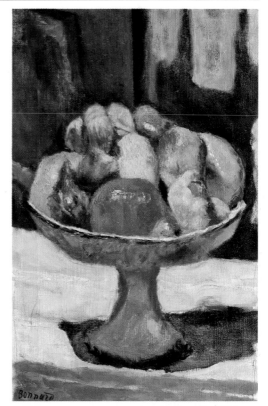

Bonnard's still lifes, like Chardin's, capture the flavor and scent of fruit in succulent color and texture; and like Cézanne's, they have a strong underlying structure. Above: *The Compotier,* with its tightly compressed composition, has a solid, sculptural air; Left: the supple *Bowl and Plates of Fruit,* arranged on looser lines, is equally well-constructed.

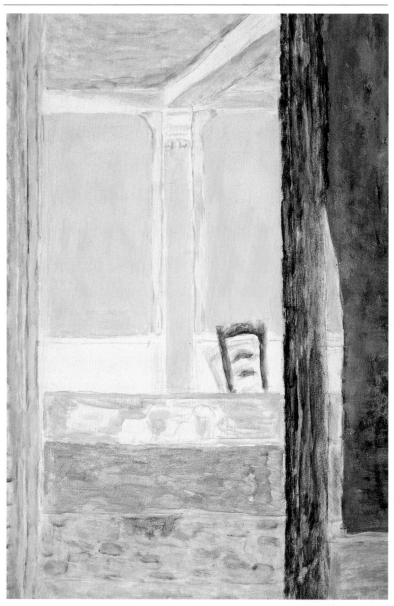

Although he had numerous admirers, Bonnard also knew that his art was deemed "decadent," "bourgeois," and "old-fashioned" by many painters and critics. The "reactionary" themes of his paintings were condemned. Indeed, he remained loyal to nature and the humble subjects of the everyday. Time and the seasons still counted in his oeuvre, where the sun continued to mark the hours.

CHAPTER 5
"A PAINTING IS A SMALL, SELF-SUFFICIENT WORLD"

Left: from his garden in the evening Bonnard could see into the lit dining room of Le Bosquet. This gouache puts all the primary colors into play. Right: one of his paintboxes, showing his tests of several pale shades on the inside lid.

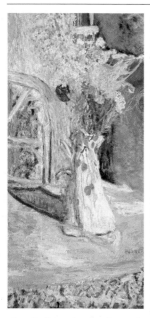

Afer his successful American visit, Bonnard took up his work again. He returned to Paris to finish a city street scene, Café "Au Petit Poucet," for Georges Besson, who had commissioned Place Clichy. This was his last large-scale urban painting. He then went home to the silence of Vernon and worked, ardently, on large views of the Seine and other landscapes. From November 1930 to April 1931 he rented Villa Castellamare, a charming house in the winter resort town of Arcachon, and there painted two notable works: Dining Room Overlooking the Garden and Stepping out of the Bath. In the fall of 1931, he moved to the Midi, to the villa at Le Cannet.

Left: the vertical composition, refined draftsmanship, and bright colors in these Flowers, painted in 1933, are characteristic of Bonnard's art during this period.
Below: a page from the painter's journal, in which sketches and patterns mix with art ideas and daily notes about the weather: "fine...overcast...cloudy ...landscape in space...an interesting background... intimate landscape with expressive objects..."

Living in a pink house

He had bought the house in Le Cannet in 1926, christened it Le Bosquet (the grove), and carried out some renovation work, which was complete by the end of February 1927. He invited Henri Matisse to visit, writing, "You will find our house on avenue Victoria; it is the highest street in the neighborhood—the house is pink." He and Marthe stayed there often, and after 1931 they made it their home. The countryside, like that of Vernon, was magnificent. In the distance, one could see the red roofs of the town, the Esterel mountains, and the sea.

His paintings captured every room—the dining room, the small sitting room, the

bathroom, his studio; these domestic interiors were a setting for images of Marthe at her daily tasks, flowers on the mantelpiece, a basket of fruit on a red cloth, a glimpse of the garden through the French window.

The upstairs studio was not large. It was furnished with a stool, a chair, a narrow sofa, and one or two small tables scattered with tubes of pigment, bottles of oil, brushes, and rags. Light entered through a bay window and played upon the white walls where Bonnard set his canvases. "I don't like to paint in grand rooms; they intimidate me," he said. "My luxury is my painting."

He kept a little journal, recording observations made on strolls in the neighborhood and thoughts that came to him while working. These notes were usually brief, but often developed into themes to which he returned over the months, focusing his ideas. Some began as simple comments on the weather: "fine," "cold," "cloudy." Then one might expand: "The weather is fine but cold; there is violet in the gray, and vermilion in the orange shadows." He also made quick sketches—faces, landscapes, nudes, seascapes—that were wonderfully lively, within the small format. These private jottings document the primordial connection in Bonnard between looking and reflecting—between, as he wrote, "the model before one's eyes, and the model in one's head." He was continually considering all the possible ways to transpose what he saw into painting.

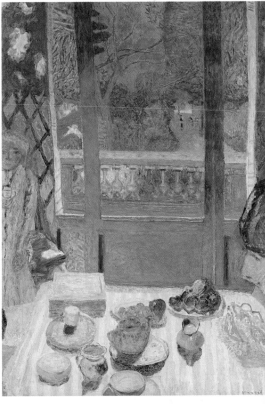

Dining Room Overlooking the Garden was painted in the Villa Castellamare in Arcachon in 1930. Three subjects in one—the garden, the room, and the familiar still life on the table—interact and vibrate in a harmony of flamboyant colors and dazzling golden light.

"This outdated passion for painting"

A great debate was raging in the art world in these years. After Cubism, after abstraction, could one continue to paint nature? Did painting as Bonnard conceived it still exist? In 1930 the poet Louis Aragon, a founder of the Surrealist movement, wrote a polemical essay, *La Peinture au défi* (*Painting as Defiance*). "It can be stated," he declared, "that in the near future painting will become an anodyne amusement for young girls and old provincials."

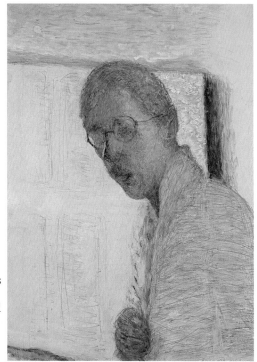

In this climate, Bonnard was seen as old-fashioned, and some critics spoke harshly of his work. Disturbed by these diatribes, he painted a series of probing self-portraits, expressing deep concentration and a reflective desire to understand himself as an artist. He turned to portraying his own image not through egoism, but as an aspect of the intimate, solitary dialogue with art that he had always pursued, and that now became a dialogue between himself and himself. These highly serious portraits bear witness to his absolute sincerity. One done in gouache and watercolor in 1930 was followed by a large 1931 canvas, simply titled *The Boxer,* in which he depicted himself in half-length, nude, and with his fists raised. He wears a strange expression of infinite sadness, but his boxer's stance conveys an energetic challenge—perhaps to himself. He exhibited the work in 1933, writing to his nephew Charles Terrasse, "I am working a lot, immersed more and more deeply in this outdated

This *Self-Portrait,* done in gouache and watercolor in 1930, is the only self-portrait that Bonnard dated. He had admired Chardin's famous painting *Portrait on the Easel* in Paris the previous year, and may have been influenced by it.

passion for painting. Perhaps with a few others, I am one of its last survivors."

Color magic

In June 1933 he opened his first exhibition of new work since 1928, at the Galerie Bernheim-Jeune. Among the thirty or so paintings were many painted at Arcachon and Le Cannet. The latter bore simple titles—*The Bedroom, Morning, The Bathroom, Cupboard, White Interior*—that did not reveal how together they comprised a composite portrait of his home. They displayed every room in it, but reconsidered, enlarged, transformed. The

The Bathroom is enlivened by rich coloration and scintillating patterns. The repeated squares and diamonds of the tile work recall the paintings of Bonnard's youth and the explosive colors transfigure this prosaic subject.

Overleaf: *White Interior*, a view of the small sitting room at Le Cannet.

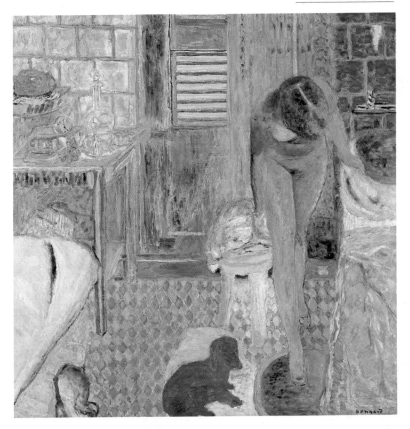

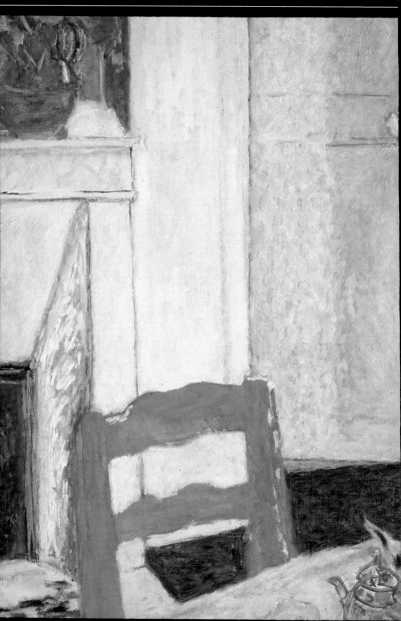

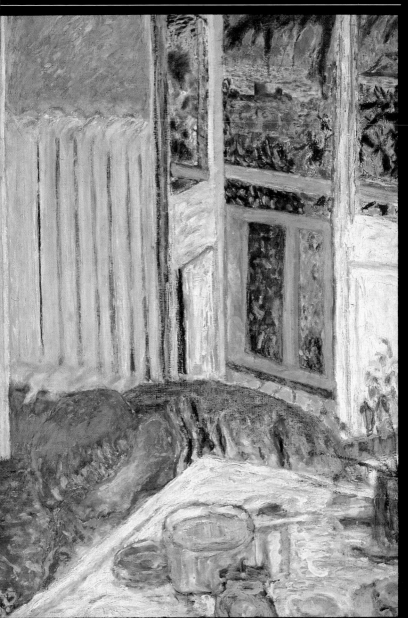

simplest rooms became the halls of an enchanted palace.

In these paintings the subject tends to be subsumed within a magical world of color and pattern. White has acquired great power, strengthening the intensity and luminosity of colors by its proximity to them. *The Bathroom* is among the most complex of Bonnard's color essays: a double harmony of blues on the left and complementary orange-pinks on the right, with touches of the theme colors from each side flecking the other to establish a gradually accelerating link among the tones.

The preeminence of light

Light impregnated his canvases in yellow flashes, causing the colors to vibrate as if in a furnace. Light cast a spell

Above: Galerie Bernheim-Jeune during the 1933 Bonnard exhibition. Below: *The Yellow Boat,* begun at Deauville in 1936. "It was [the painter Eugène-Louis] Boudin who told me about Deauville. He maintained that no other place in France was so beautiful and varied, and I must say he was right."

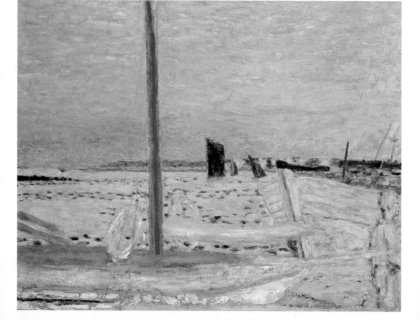

over faces and objects. Though golden and orange tones appear in all his canvases, they dominate some: *The Yellow Boat,* painted in Deauville, *The Gulf of Saint-Tropez,* and others. In his journals, he wrote often and with conviction about the presence of light in painting. His thoughts returned repeatedly to the idea that a painting was a world unto itself, a double expression of what he saw and what he imagined.

Bonnard went to the Atlantic coast of France in October 1933, staying until April 1934 at the Villa Nirvana in the town of La Baule. This was the first of several prolonged visits to the seaside and the resorts along the English Channel. From May through August 1934, he lived at the Villa Grand-Liouville, in the Normandy town of Bénerville-Blonville, in a "very pleasant [house] on the sea." Between 1935 and 1938 he spent most of his time in Normandy, at Deauville. Much as he loved the Mediterranean Sea, he deemed the northern light, "which never ceases to change," sometimes even more interesting.

In March 1934 Wildenstein Gallery in New York exhibited forty-four of his paintings. Bonnard made a short trip to London the following May for a show of his work at the Reid and Lefevre Gallery. He won second prize in the Carnegie International Exhibition in 1936, and in July of that year was elected a member of the Royal Academy of Belgium. Following exhibitions in Oslo and Stockholm in early 1939, he was also elected a member of

There is a simple sketch for this *Window at Trouville* in the artist's June 1937 journal. Here, the window is viewed sidelong, allowing a glimpse of the port. The composition is structured along a diagonal that culminates at the corner of the table, heaped with sweets.

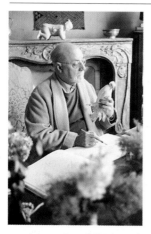

the Swedish Royal Academy of Fine Arts.

"A daily activity, like prayer"

When war was declared on September 2, 1939, Bonnard was staying in Paris, but promptly left for Le Cannet. France fell to the Germans in the spring of 1940. During the German occupation, Bonnard remained in the south. He did not go to Paris and refused to participate in exhibitions there, although some of his paintings did appear in galleries and Salons, lent by collectors. He was deeply affected by the defeat, and sought emotional refuge in concentrating on his work as much as possible.

Matisse visited him at Le Cannet in early 1940. On January 8 he wrote, "I take pleasure in writing you that my first thought this morning was about you. I still have a very precise memory of your work, which I find surer than ever. I can still see the decoration with its rose tree, and I am delighted by it."

Bonnard quickly answered him: "I am pleased that you like my explorations. When I think of you, I think of a spirit cleansed of all the old aesthetic conventions. This alone allows me a direct view of nature, the greatest good that can come to a painter. That I benefit from it somewhat is thanks to you."

The correspondence between the two painters over the years had consisted mainly of simple cards and notes. But it continued faithfully during the difficult war years, and they met whenever possible at Le Cannet, Nice, and Vence.

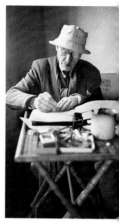

Left: Henri Matisse; right: Pierre Bonnard, artists photographed by Henri Cartier-Bresson.

"A painting is an ensemble of flecks of paint linked together," said Bonnard. And Matisse responded, "A painting is composed of a combination of variously colored surfaces." Ensemble of flecks; composition of surfaces—this is the fundamental difference in technique between the two painters.

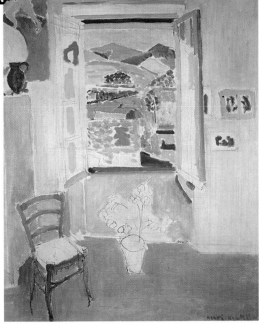

Both attempted to overcome the anxiety of the times through work, and they supported one another's commitment to art. "Like lay brothers of an invisible monastic community," wrote the art historian Jean Clair, "the two painters exchanged [news of] their problems great and small, and of their modest joys. For they both knew, without saying so to one another, that they were engaged in a service at which they excelled infinitely, and which they must not allow to falter. Nothing must impede this mission, at once absurd and sublime: to paint paintings. Hardships might mount; the firmest

Bonnard bought Matisse's *Open Window, Collioure* from the Galerie Bernheim-Jeune in 1912, and never sold it. And Matisse always kept Bonnard's *Soirée in the Salon*, which he had purchased at Bernheim-Jeune the previous year.

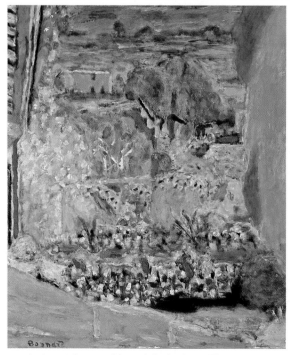

Bonnard

Landscape at Le Cannet with Red Roof is seen from a high vantage point, as though through an open window. Its composition is surprising: a distant vista framed by thin slivers of nearby objects. The rim of a roof can just be seen along the bottom of the painting; a bit of a shutter is visible at the extreme left; a broad expanse of unin-terrupted bright green bush rises along the right edge; and at the very top, the sky is a band of turquoise blue. Garden and countryside spill between these marked edges like a shower of pebbles in repeated small flecks of color.

Right: *Stormy Sky over Cannes* is composed of a sequence of hori-zontal layers. At bottom is a barrier of dark green; beyond it, tiny flecks of bright yellow and orange and sudden spots of white are clustered houses and rooftops; above these is the expansive blue ribbon of the sea. The overcast sky, with its deep contrasts of light and shadow, occupies the largest area of the canvas.

certainties might crumble and the body itself unravel, but a grounding stronger than these would remain, a place in which nature is the domain of faith rather than knowledge: where art is a daily activity, like prayer."

"It must ripen like an apple"

The "decoration with its rose tree" that Matisse mentioned was *Terrace in the Sun,* a long, horizontal canvas that Bonnard began in 1939 and worked on intermittently throughout the war, finishing it in 1945. This long span of time was often a part of his working method—a response to an internal need. He painted with small, rapid strokes, pausing for long periods to consider what he was doing. He always worked on several paintings at once and would let them sit unfinished for a time, so as to assess them with a fresh eye. He would step back from a work in progress to

judge its effect at a distance, and would then remove or add.

In addition to working on a painting at length, and on many paintings at once, he also commonly made several versions of a subject—a nude, an almond tree in blossom, some peaches. These were all methods of confronting and investigating ideas in depth, and of finding new ones. As time passed, he hesitated more and more to sell his paintings. "Bonnard," wrote the art curator Philippe Le Leyzour, "is the sort of painter who almost never admits that a painting can be finished, but who through unending work makes it the symbol of his own consciousness."

Above: Bonnard at work in his studio, with several canvases tacked to the walls, including, at left, *Landscape at Le Cannet with Red Roof.*

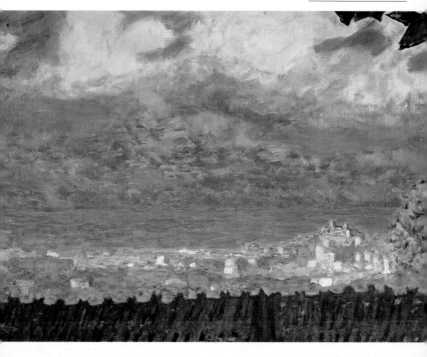

"To bring painting to life"

Day by day, in voluntary exile, he pursued his private dialogue with nature. Because of the war and his own increasingly narrow focus, his universe had been reduced to the countryside around Le Cannet. A "voyager around the neighborhood," he would leave the house early in the morning and walk along the banks of the little Siagne canal or climb into the hills. "It is wild there, and I can meditate."

He had long known that the visible world and the world of painting were two distinct worlds, and he now felt this ever more acutely. Nevertheless, he could not separate the two in his art. He wrote to Matisse in late February 1941 that he needed "constant contact with

A bove: Bonnard standing near *Saint Francis de Sales,* in a photograph by Henri Cartier-Bresson.

"An ensemble of flecks of paint…ends up forming the piece, the object over which the eye wanders without interruption." Bonnard always maintained the importance of color. "Color *acts,*" he told the painter Charles Camoin (1879–1965), summing up its power in a single word. He made color the unifying element in his painting: the living link that knits together radiating space. Left: *Garden at Le Cannet* celebrates unexpected harmonies of green, violet, blue, and mauve, touched with turquoise.

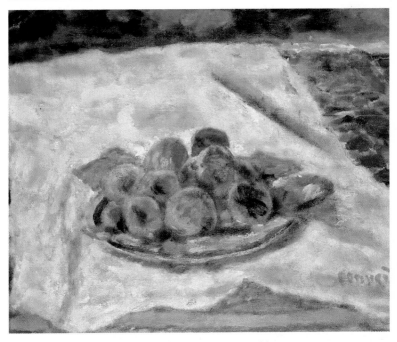

nature," adding, "today I saw the first almond tree in blossom, and the mimosas are starting to put forth patches of yellow." For him the dialogue with nature had become a dialogue with painting. "In painting, you will never succeed in rendering reality when it is already perfect. The point is not to paint life, but to bring painting to life."

As the war ground on, he was struck by a personal tragedy. Marthe Bonnard died on January 26, 1942. He confided his sorrow and despair only to a few intimates, such as Matisse. It was then that a cleric, the Canon Jean Devémy proposed that he create a painting for a church in Assy, in the Haute-Savoie district. He thus began *Saint Francis de Sales Blessing the Sick,* a very large painting, although he did not finish it until 1945. He continued to receive other commissions as well. Louis Carré, a Paris gallery owner and publisher, asked him to paint a series of gouaches for transfer to lithograph. The artist Jacques Villon (1875–1963) made the transfers; this

"Peaches are astonishing. This year I was much struck by them," Bonnard said in 1942, referring to *Plate of Peaches.* He painted some four or five fairly large canvases of the fruit. "This is a violet harmony," wrote the journalist André Giverny in 1942. "The peaches, heaped one upon the other, are like a sky at the very end of sunset, when only the golds and one or two spots of white remain. Surrounding this silent symphony is the tablecloth, whose white is varicolored gray and pink."

Left: this striking, defiant *Self-Portrait,* done late in Bonnard's life, shows no self-indulgence or charity: the artist views himself with the same critical distance that he at times imposed on other subjects. This is an internal examination of self, made at his own expense and taking more from him than it gives. In the end, may it not be said that Bonnard lived at a remove from the world, sacrificing all to his passion for art? "What," he exclaimed, "would a painter be without painting?"

"But, you will say, if Bonnard was silent at this point, and if all those who took a deep interest in painting were also silent, how would one go about approaching him? How would one have a discussion with him? Quite simply, through sincerity. Above all, Bonnard was an absolutely sincere man, which is not an easy thing. But he managed not to shock anyone. He said what he felt and perceived, and swiftly found the best way of expressing it."

André Beucler,
Plaisirs de mémoire
(*Pleasures of Memory*),
1982

was the beginning of a collaboration between the two that lasted from 1942 to 1946.

Young painters came to see him. He welcomed them and generously helped those he knew were experiencing difficulties. He wrote a certificate stating that Paul Ackerman worked for him; he gave half of his precious stock of color pencils and chalks to Henri Goetz and Christine Boumeester. "Thankfully, I was able to start working again," he told them.

At the beginning of 1944, in preparation for battles to come, the occupying forces considered evacuating the population of the Côte d'Azur. Bonnard remained in his house at Le Cannet, where he did "useful work for France," as he wrote. Although he continued to paint radiant pictures, he wrote in his journal, "He who sings

is not always happy." His deep distress is expressed in the anguished self-portraits he painted during the war years.

"I am only beginning to understand"

The war ended in France in May 1945, and he returned for the first time to Paris in July. That year his nephew, Charles Terrasse, a curator at the national museum, organized an exhibition of contemporary painters at Fontainebleau. These were works owned by private collectors and by the Bernheim gallery, which had been stored in the chateau during the war. Ten of Bonnard's canvases hung alongside works by Braque, Matisse, and Kees van Dongen (1877–1968). Later that year his niece, Renée Terrasse, returned with him to Le Cannet and settled nearby.

In June and July 1946 he was once again in Paris for a large exhibition of his paintings—the first postwar show at Galerie Bernheim-Jeune. At Louis Carré's gallery he met the critic André Lhote and the artists Jean Bazaine (b. 1904), Marc Chagall (1887–1985), and Jacques Villon. He visited the Salon des Réalités Nouvelles, the first major exhibition of nonfigurative art in France. While admiring some of the investigations of abstraction, he reaffirmed his conviction that art would never be able to

Morning, begun in 1940 and finished in 1946, exalts the blazing daylight of the garden in which the dining table is set. "Never has light seemed so beautiful to me," Bonnard told Jean Leymarie.

abandon nature totally. "If one forgets everything, all that remains is oneself, and that is not enough."

He was 79 years old, a much-honored artist and greatly in demand. Yet he never lost his sense of proportion and his personality remained sincere and ingenuous. Invited to visit the Louvre in the company of Georges Salles, director of French museums, he gazed in delight at the nearby riverside quays in the evening light, confiding to a young assistant curator named Jean Leymarie that "the most beautiful things in museums are the windows."

In October of that year Bonnard once more came to Paris and spent a few days at Fontainebleau, where he completed two major works, *The Studio with Mimosa* and *The Circus Horse.* The latter was exhibited at the Salon d'Automne,

Above: *The Circus Horse,* 1934; below: early sketches for it.

along with *Morning, Red Roofs at Le Cannet*, and *Leaving the Port of Trouville*. His health had been in decline for some time and now began to worsen rapidly. He was very weak when he returned to Le Cannet, but he continued to work on what was to be his last painting, *Almond Tree in Blossom*. In January 1947, barely able to hold a paintbrush, he asked Charles Terrasse to change a color that bothered him in the lower corner of the canvas. "This green doesn't work," he explained, "it needs yellow." Until the last moment he was fully a painter, bedeviled by the problems of art, although he modestly said, "I invent nothing. I observe."

A few days later, on January 23, Pierre Bonnard died.

Below: *The Studio with Mimosa,* completed in 1946. Like sun passing through stained glass, the brightness of the mimosa's yellow pierces the window panes of the studio.

Overleaf: *Almond Tree in Blossom,* Bonnard's last work. The repeated flecks of snowlike white brighten this lyrical, valedictory painting.

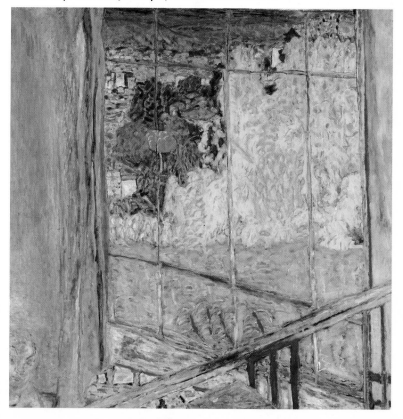

DOCUMENTS

"The whole pictorial effect must be presented
through the equivalents of drawing. Before applying color,
everything must be seen once, or a thousand times."
Pierre Bonnard

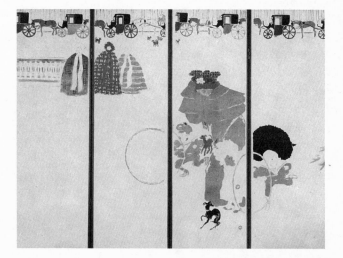

Letters

Bonnard exchanged letters over many years with the painters Edouard Vuillard, Claude Monet, and Henri Matisse; three correspondents, three different styles. His friendship with Vuillard was a true meeting of minds. His neighbor Monet was older than he; the two generally wrote brief notes. His correspondence with Matisse was of another order; the writer Julien Gracq said that they seemed "like two Benedictine monks…helping each other, without pettiness or self-regard, to embrace the truth a little more fondly."

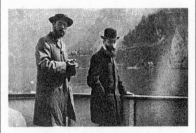

Bonnard and Vuillard photographed by Ker-Xavier Roussel at Lake Como, Italy, 1899.

Previous page: *Nurses Taking a Walk, Frieze of Cabs*, five-color lithograph, 1897.

The friendship between Bonnard and Vuillard dated from their earliest studio years and lasted until the latter's death in 1940.

Bonnard to Vuillard:

April 13, 1891

My dear Vuillard,

You can imagine the pleasure your letter brought me. I read it several times, savoring it. An "official" painter who takes our painting seriously and who believes that we really want to make art: now that's an occasion!

And how truly nice that you should have been there. The conversation you had with him—and then his visit to you—must have made a great impression on him.

You think I don't want to do business with him? I asked him for 100 francs and his permission to visit him when I return to Paris.

I think he will find the price reasonable, but I would just as soon give him the painting for nothing.

I am waiting for my brother to get a bit more established socially before I return too. But I'm sure I'll come back before August. I'm preparing some work here that I'll be able to finish in Paris. I'm not sure how to get something out of my project *Le Solfège* [that is, the illustrations for the book by Claude Terrasse]. I must look for encouragement to the artists of the past who illustrated missals and to the Japanese, who put art in encyclopedias.

My very best regards, and thank you for your thoughtfulness.

P. Bonnard

P.S.: I've done an excessively proper little painting. Am I becoming classical or senile?

Vuillard to Bonnard:

Sunday, August 7, 1897

Dear old Bonnard,

Hey! How's the trip going? Your ears must have been burning last night: someone was talking fondly about you to me. Guess where? At the home of that fat lady on rue Tronchet, whither the long-lost Hoonschel had invited us. This time Heidbrinck kept his cool to the end. The fat lady was quite friendly, Carrier quite boistrous, Grasset quite calm, and Hoonschel quite fidgety. Everyone truly missed you, and Carrier in particular wanted me to tell you so, and sends you his greetings.

Three days earlier, I would not have been able to go. Imagine! I stupidly got sick and was in bed for four days and housebound for another three. Apparently I caught a chill. Now that it's past I'm not complaining—it changed some of my thoughts, which had not been particularly cheerful, and some of the time I spent at home was good. The evening before I took to my bed I had gone to Saint-Germain to bring our paintings to [Maurice] Denis. I made the trip with [Paul] Sérusier, whose bad news you must have heard: his mother, who had gone to meet him in Huelgoat, died. I believe he feels it as a great loss, a very great loss; she was a good influence on her son and had faith in him. What's more, he's borne his sorrow in a really touching and simple way. Denis always had a happier air in his painting, calm and committed.

You'll have learned from the newspapers about Lugné [Aurélien Lugné-Poë] and [Marthe] Mellot's bad luck. I saw both of them. Lugné had a very worn air, though he says that it's not because of his exam nor his impending military service. But as he was showing

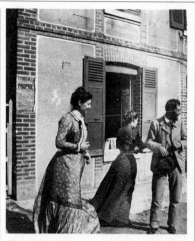

Bonnard and two friends at Cricquebœuf in Normandy, 1901.

a great deal of reticence I didn't understand much, other than that he was suffering deep personal sorrows. Mellot has left the Conservatory and is looking for a job. Georges Roussel is still in love. I'm writing to you in a rather disjointed manner. I was at Aucier's, but saw nothing good there. I got the publication from the Théâtre d'Art in which your drawing is handsomely misprinted. I have the issue of the magazine that belongs to you at home. All of that is ugly; best not to think about it. As for me, Arsène Alexandre gave me a very nice review in *L'Eclair* in an article on Cadet's collection. I swear I liked it.

I've been rather letting my work go. Now that I'm back in Paris and all alone, I hope to get on with it. Here and there, I see a few birds of passage, such as Collet, whom I visited yesterday afternoon. But mostly I'm alone and trying not to get too bored. There are even times when I'm relatively

happy, like this morning, when I took a short, pleasant walk through the Tuileries [Gardens] and to the Louvre.

And you, my dear old Bonnard—what about you? If you have a moment, drop me a line—you know I'd like it. Give my best wishes to [the painter Paul] Ranson and his wife when you see them. I don't have any real news about Ker [-Xavier Roussel]. I hope things are going well. Have fun. My best wishes and a hearty hug.

E. Vuillard

Vuillard to Bonnard:

9 rue Wesembeke,
Anvers [Belgium, November 1892]

Dear old Bonnard,

May I ask you to take care of some business for me? I will explain all these things later.

1. The screen: I beg you to do it. I wrote to Thadée [Natanson] and Stéphane [Natanson] who will speak to you about it.

2. Boutteville [the gallery owner Louis-Léon Le Barc de Boutteville]: tell him what you want. Bring him the little blue *ravaudeuse* [a painting of a woman sewing] that I forgot, and take care of hanging my canvases. Tell him that the price for the pastels is between 80 and 100 [francs], or even less, but use your judgment about the paintings; they should sell for between 150 and 300…

The last few days since last Thursday have been rather tiring and I'm only now able to relax, but I don't know what to write.

I send you my best and ask you to manage this business for me.

E. Vuillard

Ker sends both you and Denis his greetings.

B onnard and Claude Monet in Monet's garden at Giverny, c. 1925.

Bonnard to Vuillard:

Grand-Lemps.
Sunday, undated [postmarked October 15, 1893]

My dear Vuillard,

How nice of you to trace me to my burrow. Not to mention that I'm happy to have news of you and our friends. I'm in no danger of being disturbed in my contemplative solitude, as two things are occupying all my time: First, these past twenty-eight days (I shall tell you how hard the work was); and second, *Le Solfège* itself, which is being printed this very minute! I can't begin to describe all the stages of this project—it would take volumes. What I do know is that it used up my whole vacation, but I still can't return because of this wretched book. In the first attempt to print it—and there have been many—my brother-in-law and I reached the point of running the printing press ourselves. Unfortunately, we found that we had to turn to a well-equipped printer. May heaven help us! So now I'm going gray trying to get the impossible from the printer. Still, I'm

thinking about returning and won't dawdle, as soon as it's possible.

To be precise, by the end of this week or the beginning of the next I may be in Paris. What shall we do for that exhibition you mentioned to me? I have nothing here; in Paris I only have a few unframed studies from the spring, and I don't know what I think of them now. These twenty-eight days have given me a hole in the head. What would be the absolute deadline? If it's a rush, I can only think of offering the life-size *Head of a Woman* on a size 8 panel, and the *Street at Eragny*. A very thin trimming will suffice for the first, and for the other, a 10- or 12-centimeter pine board. If Boutteville wants the first

ones without frames, we can send them that way, and it will be much simpler…

In any case, I'll try to slap some paint on a canvas, and if I'm happy with it, I'll send it with a small frame made here. So if it's needed this week, I definitely will not be back. Oblige me by bringing the canvases to Boutteville and if necessary ask him to take care of the framing per my instructions. My dear Vuillard, I think of you often, although not much arrives at the post office. I count on making up for this long silence soon with a good chat, as Lugné would say.

Best to you,

P. Bonnard

Greetings to all.

Monet and Bonnard usually sent each other simple notes to arrange meetings at their studios. But in this sober letter, the older painter describes his worries about the gift of his great Nymphéas *(Water Lilies) panels to the French government.*

January 19, 1925

My dear Bonnard,

I am late in thanking you for your good wishes and your lovely letter. But I began this year poorly, in a crisis of total despondency, for the time was approaching when I would have to deliver these panels. I am obsessed by this and curse the idea that I have had to give them to the nation. And I was going to be obliged to send them in a deplorable state, which makes me thoroughly sad. I am doing what I can to pull myself together, but without hope.

My best to your wife and you. Blanche joins me and asks me to thank your wife for her kind letter, until she does so herself.

Yours,

Claude Monet

A note from Monet to Bonnard: "I would be very pleased to see you, if you have a moment free this morning…"

The letters of Bonnard and Matisse touched on many subjects, from the prosaic matters of daily life to deep artistic questions. The two friends pursued an ongoing reflection upon the painter's craft. "A painter exists with a palette in his hand," Matisse said, and Bonnard agreed. These letters are translated by Richard Howard.

Matisse to Bonnard:

January 28, 1935

My dear Bonnard,

I advise you as well as your wife to take every precaution to avoid the flu, which is everywhere at the moment. About ten days ago I caught it quite thoughtlessly: I stayed in a draft I should have avoided. There are times when I consider myself to be very strong; I paid for that. I was in bed five days with fever and bronchitis, which is not over yet. Of course I had to leave off my work, and since I had been really applying myself, it became my invalid's obsession, and after repeatedly scrutinizing my conscience, I had several thoughts which I wrote down for your benefit but later tore up. Such reflections are part of the flu. I had no right to inflict them on you, any more than to send you my flu microbes. In conversation, things take on a lightness that lets us say anything. You can share your thoughts with someone who has prepared the ground. But writing is more difficult. The other side of the question becomes evident of its own accord and paralyzes you. In truth, a painter exists with a palette in his hand and he does what he can. But let me tell you anyway, like all the old men, that theory is something rather sterilizing or impoverishing. This has already been said so often that it no longer has any resonance. I'd have to go back at least 20 years. My dear Bonnard, you see that I have not yet recovered. I shall continue to take care of myself. I'll tell you when the flu is completely gone, so that if you happen to come to Nice you can stop in and see me without danger.

In friendship to you both from your devoted,

H. Matisse

Mon cher Matisse
Vos 2 tableaux decorer
c'est le mot ma salle à
manger sur un fond

Bonnard to Matisse:

February 1, 1935

My dear Matisse,

I hope this letter will find you completely recovered and in good condition—it was kind of you to have alerted

B onnard writes to Matisse, May 1946: "My dear Matisse, your two pictures decorate (that's the word) my dining room, against an ocher background…"

me about your microbes and the rest. I, too, had a brief touch of flu but without any fever, and I am still very careful not to try to act like a young man. That will make us appreciate the warm breezes which can't be long in coming now.

I've managed to work anyway, with a sore nose and a burning throat. I have some thoughts about

Henri Matisse in 1942.

it, they last as long as the day. I agree with you that the painter's only solid ground is the palette and colors, but as soon as the colors achieve an illusion, they are no longer judged, and the stupidities begin.

For the moment I go walking in the countryside and try to see it the way a peasant does.

I hope to see you shortly, don't go out too soon, the temperature is deceptive.

P. Bonnard

Matisse to Bonnard:

[Hôtel Régina]
January 8, 1940

My dear friend,

I take pleasure in writing you that my first thought this morning was about you. I still have a very precise memory of your work, which I find surer than ever. I can still see the decoration with its rose tree, and I am delighted by it. Your blue seascape, too, and I am sorry I didn't get a good look at the bouquet of roses. I promised myself I would see it before I left but

the time was too short and the interest of the conversation (I was talking about myself) prevented me. Be of good cheer, my old friend, your work is going well.

Both of us have had relatively good health, given the changes in the weather. This morning it is warm and beautiful. That will continue.

My friendliest wishes to you both.

Henri Matisse

Bonnard to Matisse:

[late February–early March 1940]
My dear Matisse,

I hope you will soon be well again despite this new winter chill, which in any event is healthier than that horrible fog we suffered from here as well. I almost ran out of coal, there wasn't any more in Cannes, and they brought me a truckload from Nice. So now we can relax. My work is going pretty well, especially in the direction of understanding. During my morning walks I amuse myself by defining different conceptions of landscape—landscape as "space," intimate landscape, decorative landscape, etc. But as for vision, I see things differently every day, the sky, objects, everything changes continually, you can drown in it. But that's what brings life. I hope that as the days grow longer I will soon be able to come to Nice, and will be happy to see you.

Our friendliest wishes,

P. Bonnard

Bonnard through the eyes of his contemporaries

"First one sees his eyes, the eyes of a child listening to a story. Bonnard's conversation takes little tastes of things. He has the air of one who pecks about the vines, but that's merely his style. There's a naive hesitation in his words, but it's the idea that is laborious, not the tone."

Léon Werth,
Bonnard, 1919

The painter Maurice Denis met Bonnard in art school and knew him for many years.

"Admired by both fools and the wise"

I know Bonnard's age, having been his friend since the Académie Julian in 1888. But I cannot believe that more than half a century has passed since then, for his painting remains young and faithful to the youthful spirit of his first works. (This is not to say that that spirit has not expanded greatly during this long period, and gone through many styles.) The privilege of not aging has earned Bonnard the approval of the young. He is the most modern and

This c. 1910 drawing based on a watercolor by Bonnard shows (from left) Edouard Vuillard, Ker-Xavier Roussel, Pierre Bonnard, Henri de Toulouse-Lautrec, Tapié de Celeyran, and Maurice Denis in Place Clichy in Paris.

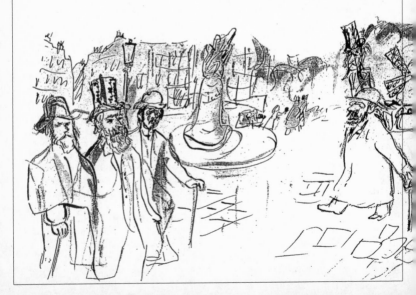

advanced of today's painters; he has his place in the contemporary art market. He certainly prefers to be a respected master, admired by the younger generations, rather than a member of the Institute [Académie des Beaux-Arts], where Vuillard wanted him to apply for admission.

The majority of these young admirers, I believe, appreciate the disorder of his compositions, the audacity of his dissonances, and his fantastic imagination. They like his unpredictability, the spontaneity of his technique, his distortions, his omissions more than the profound qualities of his color and draftsmanship. Since his system consists in having no system, he easily escapes analysis. Nonetheless, some of his portraits have an intensity, a truth, a density—in the modeling and subject matter—that also satisfy other, more difficult minds. Moreover, his gifts as a colorist can best be judged in the recent still lifes, where color is carried to extremes. Thus, he is admired by both fools and the wise. One never grows tired of seeing Bonnard's work. Nor does one grow tired of arguing about it. He delights the subtle and provokes the curiosity of the aestheticians. He charms, he disconcerts, he scandalizes. Sometimes his painting yields immediately to our pleasure; sometimes it closes itself off, resisting the interpretation of viewers. His painting is at times naive, at times complex and challenging… Both the circumstances of the times and his own mischievous mind made him

a painter of modern life. He observed people, animals, and things with a smiling irony. He liked dense landscapes, as in the green fields of Beauvais; he liked Paris, the Seine valley, cheerful interiors, and fair skin. Where Degas brought tubs and baths into his studio to use [in arranged tableaus] as a pretext for refined studies of movement and form, Bonnard used [bathtub scenes] in order to paint delight, almost always working from memory and guided by an exquisite feeling for feminine grace and color. His color is subtle and sparkling, enriched by reversals of color values. He uses it with masterful control, not as an attempt at atmospheric perspective, but rather to depict a subjective truth that seeks to convey sensation and indeed imposes itself irresistibly on the artist.

This free-spirited and impulsive art seems remarkably able to evade a reality that it cannot really do without. Bonnard eliminates all that is prosaic, retaining only appearance and emotion, translated into a language that is appropriately and exclusively pictorial, "with nothing heavy or static in it." These intimate moments—these dreaming young women who brush their hair, or undress, or sew, or read, these bathers with their graceful torsos and rosy thighs—all are imbued with tenderness, with optimism: in a word, with poetry…

But Bonnard also has the gift of magic, the gift of the fairies that can metamorphose a yellow pumpkin into a golden carriage. Like them, he has the power to make a banal dessert into a dazzling symphony; under his brush, the painted bathroom becomes a setting for *The Thousand and One Nights.*

Tricks with light, enchanting visions— or rather, tricks with paint, the passion-

ate experiences that his instinct invents and his taste impels. His is the gift of perpetual surprise, and it is ours too, linking us to his insatiable delight in painting.

Maurice Denis,
"Bonnard," *Le Point*,
special issue 24, January 1943

"To tell the truth, I have trouble with painting"

Ingrid Rydbeck, a Swedish journalist, interviewed Bonnard in his studio at Deauville in 1937.

On a somber, rainy afternoon, our taxi stopped in front of a humble little country house on the outskirts of Deauville, near the port. Before us was the open sea. If we had any remaining scruples at the thought of disturbing an artist who clearly loved his peace and quiet, these vanished the moment an elderly gentleman, friendly and smiling, stepped out of his small car, parked in the courtyard, and walked toward us. It was Monsieur Bonnard; I recognized him from a photograph I had seen in *L'Art vivant*.

"I hope you haven't been waiting. I'm coming from town, where I had some shopping to do. Please come in; this way."

On his face was the sort of smile that often lights up the countenances of sensitive, profound men. He led the way up a narrow staircase. We followed, weighted down with our cameras, lights, and briefcases. We entered a room, most likely originally the dining room, with scattered furniture and two wide-open doors. A balcony looked out over the harbor and the sea. In the middle was a Breton table covered with painter's supplies: a small palette, a box of watercolors, and a few tubes of gouache on a newspaper.

The wallpaper had a large leafy pattern, in rather good taste for a rented house. Tacked onto one wall were two canvases barely begun. Facing these were two gouache landscapes and on either side of them a few sober Japanese prints.

"It's amusing to look at the pattern of this wallpaper with its shadows and relief effects, and to contrast a Western decorative concept with an Oriental one, characterized by plain, blank decorative surfaces.

Bonnard at Deauville, 1937.

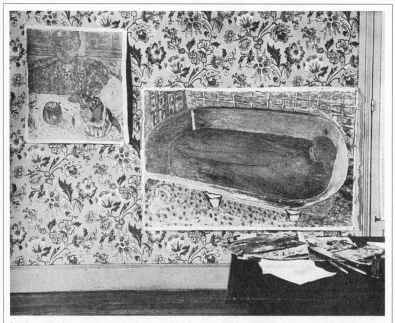

The wall of Bonnard's hotel room in Deauville, 1937. "It would bother me if my canvases were stretched onto a frame."

"We still haven't completely moved in yet," he explained, casting an eye around. "We moved from a nearby house a month ago, and my wife is not well."

"Is this where you work, Monsieur Bonnard?"

'Yes; isn't the view beautiful? You should see the sea at high tide, when the houses and boats are reflected in the water. It was [the painter Eugène-Louis] Boudin who told me about Deauville. He maintained that no other place in France was so beautiful and varied, and I must say he was right. One only comes to understand a landscape completely after a long time. After two years I feel I understand this region and begin to be able to do something."

"You paint outside, don't you, Monsieur?"

"No; almost never. It's not possible: the light changes too quickly. I do some small sketches and make notes on colors, but I paint in the house."

Suddenly I noticed that there was no easel in the studio. "Do you pin your canvases to the wall when you paint?"

"Yes; it would bother me if my canvases were stretched onto a frame. I never know in advance what dimensions I am going to choose."

"Don't you find the leafy design of the wallpaper distracting?" I asked in astonishment.

"Not at all. If the pattern were uniform, that would certainly be the

case, but this way the colors are neutralized. I don't like to paint in grand rooms; they intimidate me."

The two paintings on the wall were interior scenes. In one a woman is seated at a table with a basket of fruit in the foreground. It is somewhat reminiscent of *Basket of Fruit,* which we had seen at exhibitions of French art in Göteborg and Stockholm. It is a warm painting in bright yellow tones, very characteristic of Bonnard's later work. The other was a large canvas of a woman in a bathtub.

The two gouache landscapes on the opposite wall drew my eye.

At home in Deauville: one of the painter's palettes, 1937.

"These are not gouaches as one ordinarily thinks of them," said Bonnard. "They are watercolors with a lot of white [paint] added in. Watercolor technique annoys me—one tries to use the white of the paper to render the effect of light. To my mind, that's illogical. Moreover, I work so slowly that I must use paints that can be revised or added to continually." Smiling, he continued: "To tell the truth, I have trouble with painting."

Looking at these bright landscapes, which convey the atmosphere of sea and salt air so well, and considering these last words, I said, "Monsieur, you must have an extraordinary memory for colors and tones."

"No, not at all." From the corner of the room he picked up a box full of quick little landscape sketches. They were sketchbook sheets covered with notes on colors and marked with crosses and dots.

"I do these sketches outdoors as soon as I find a light effect, landscape, or atmosphere that moves me." He spoke again with ardor and enthusiasm about the shifting vista of sea and light: how the sky was sometimes a bright blue— bluer than elsewhere—but just as often was covered with opalescent clouds. How every moment everything changed; in the time it took to open a sketchbook, the light and atmosphere had already completely altered.

"It's a matter of noting down whatever strikes you as quickly as possible. Then afterward you take a single color as a point of departure and compose an entire painting around it. Color has a logic as exact as that of form. One must not give up before capturing that first impression."

Ingrid Rydbeck,
With Bonnard at Deauville, 1937

"He speaks little, he explains little"

Georges Besson, an art critic and friend of Bonnard since 1909, evokes the personality of the painter.

You would like some recollections? Some of Pierre Bonnard's character

traits? Your readers will be disappointed—I'm not going to recount any adventures; his life has been without picturesque incident. Is there any finer adventure than the rediscovery of this unique painter, whose every finished work contains the promise of new conquests?

Bonnard has not lived his life like Van Gogh, preaching to girls to straighten up; he did not cut off his ear. He has not lived like Lautrec, you-know-where [i.e., in bordellos]. He has cooked up no sensational Maori fashions, like Cézanne...And if he [protests on behalf of] the benefits and rights of the imagination, he does so with his brushes. He speaks little, he explains little, he does not write. Once, in 1921, he gave way to a moment of indignation, such as he occasionally has, and wanted to write a demand that rural enclosure walls be demolished, so as not to block the pedestrian's view of all the lovely green of the countryside.

I first visited Bonnard in 1909. At that time he wore wire-frame pince-nez and a short, sober beard. Below his upper lip, his two incisor teeth had been whittled down by a dentist twenty years earlier, lending him a distinctively guileless and surprised air. I hardly knew him. One morning in May I arrived at his studio, a cell in a former convent on rue de Douai [in Paris]. He sat me in an old easy chair by a yellow door, rubbed his hands together energetically (a characteristic gesture), and began to paint my portrait. As he painted, he smoked a pipe and munched pralines from a tiny paper bag on a little, round, rusty stove...

If you knew Pierre Bonnard—his bonhomie, his mischievous smile, his irony that is neither nasty nor abrasive;

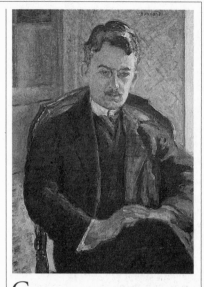

Georges Besson painted by Bonnard, 1909.

if it were possible to show you the sorrows and sacrifices of his life and the courage with which he has borne them—you would admire his personality, even if Bonnard were not Bonnard, or were less of a genius. His tolerance is infinite, and though he is sometimes stubborn, he strives never to create difficulties...

For thirty years Bonnard has [worked in many places]: in Grasse, in Saint-Tropez, a winter in La Baule, in Arcachon, in Trouville...Marthe Bonnard's state of health required these visits, with their awkward working conditions. Bonnard has had a studio in Montmartre nearly forever. He uses empty barns and warehouses. But his true studio is anywhere and everywhere: in furnished villas and hotel rooms with indescribable decor—

often a cheap light fixture in the ceiling, always that flowered wallpaper, which the paintings covered over, little by little. One, pinned up too high, hangs over the door; an even bigger one is spread out on the floor. And Bonnard, one foot on the painting and a dog, either Ubu or Poucette, underfoot, bends over and rubs a bit of shading; straightening up again, he smiles and comments that his work has been "improved."

Bonnard likes to rework his old paintings. In the Grenoble museum and again in Luxemburg he waited for the guard to leave the room and then took from his pocket a tiny box containing two or three tubes of pigment and the end of a brush, and with a few strokes furtively "improved" a detail that was bothering him. The deed done, he slipped off, beaming like a teenager who has written something naughty on the blackboard.

"I float," he says, "between Intimism and

decoration; one can't change how one's made." And: "I've gotten a few satisfying results from two years of study, and I have never stopped learning and understanding."

Georges Besson,
"Bonnard," *Le Point*,
special issue 24, January 1943

"Almost the shyest man one could imagine"

Raymond Cogniat, an art critic, interviews the artist and offers his impressions of the man.

Pierre Bonnard is the most discreet and almost the shyest man you could imagine. When you speak to him about himself, you get the impression that he has turned inward, and he has so little self-regard that you grow ashamed of asking questions, as if you were committing some unintentional indiscretion. He responds without any visible ill-humor, but one always senses that he's eager to finish the interview. He is gentle and smiling, with an air of extreme simplicity, yet the life he describes must often have been difficult, like those of all the artists of his generation.

"My father, a civil servant, did not take at all well to my becoming an artist."

"That's very traditional. Most vocations begin that way and grow strong [through opposition]."

"I don't know that the word vocation is exactly appropriate to me.

"I've gotten a few satisfying results from two years of study, and I have never stopped learning and understanding"; passage in a 1943 letter from Bonnard to Georges Besson.

I wasn't all that aware that I wanted to become a painter. What attracted me, at that time, was less art itself than the artist's life and all that it meant for me: the idea of creativity and freedom of expression and action. I had been attracted to painting and drawing for a long time, but it was not an irresistible passion; what I wanted, at all costs, was to escape the monotony of life.

"I finished my law studies, intending to join the records office; when I failed, my father had me take a job in the Paris law courts, but I didn't stay there long."

"Hadn't you studied at the Ecole des Beaux-Arts?"

"For a very short time. And also at a school of decorative arts. But most of all I attended the Académie Julian."

"You met Maurice Denis, Sérusier, Ranson, and Roussel there."

"Yes, and it was there that we first saw the magnificent example of Gauguin, and there that we began our initiation."

"In reaction against Impressionism."

"No, not at all—at least, not in my eyes. I remember very well that at that time I knew nothing about Impressionism. Gauguin's work was exciting in itself, not for its opposition to anything else. Moreover, when we discovered Impressionism a little later, it gave us a new enthusiasm, a feeling of discovery and liberation. Gauguin was classical, almost traditional; Impressionism brought us freedom."

"That explains the aspect of your art associated with Impressionism.

Bonnard, c. 1915.

Your work forges a synthesis of the two styles. Do you remember when you discovered your own means of expression—that is, your technique?"

"Definitely. It was during a vacation in the Dauphiné, at a house belonging to my family. The year was around 1895. One day, the words and theories that were the foundation of our conversations—color, harmony, the relation between line and tone, balance—lost their abstract significance and became very concrete. I had understood what I was seeking and how I would try to obtain it.

"What came after? The point of departure had been given to me; the rest was just daily life."

Raymond Cogniat,
"Les Nouvelles artistiques,"
Les Nouvelles littéraires,
July 29, 1933

Bonnard the illustrator

From 1891, the date of his first illustrations for the France-Champagne company, through 1947, when an entire issue of Verve was devoted to his work, Pierre Bonnard made drawings for books and magazines. The Louvre curator Jean Leymarie said, "Bonnard was the first illustrator whose hand was utterly free and fluid, a miracle of candor and of subtle Eastern wisdom." These texts are translated by Jean-Marie Clarke.

Bonnard contributed to several magazines, including La Revue blanche, *edited by Thadée Nathanson and Félix Fénéon;* Cahiers d'aujourd'hui; *and* Verve. *In the early years of* Verve *his work appeared alongside that of his friends Maurice Denis, Edouard Vuillard, and Henri de Toulouse-Lautrec.*

Bonnard took equal care with [his] drawings, which were chiefly designed to be commercially printed, and his own lithographs and etchings, as can be seen from his many drafts and preliminary sketches. And yet, both these drawings and the lithographs and etchings appear effortless; one has the same sense of spontaneity and freshness, the same feeling of freedom, as well as endless variety. His wide range of subject matter clearly contributed to this diversity. Alfred Jarry's *Ubu* is worlds apart from Peter Nansen's *Marie.* Nevertheless, one is continually surprised by this self-renewal, stemming from the sympathy he feels for the subject…"

Antoine Terrasse,
Preface to *Pierre Bonnard Illustrator,*
1988

Ink drawing for *La 628-E8,* 1908.

D rawing for the magazine *Cahiers d'aujourd'hui*, 1921.

The Supermale

Bonnard had published a drawing of Messalina in La Revue blanche *in 1902. Alfred Jarry wrote to him on February 18, 1902, asking him to illustrate the announcement for his next novel.*

My dear Bonnard,
 Your drawing of Messalina in *La Revue blanche* is absolutely terrific. Superexcited by the sight of said drawing, Thadée Natanson and I wish to ask you if you would not mind portraying for the next issue of the review a little *Supermale* to illustrate in the same way the advertisement for the novel. Any old fellow will do, as long as he's very naked and horrifically strong. A Herculean club, if it suits you. "Attributes" at will, but presentable, without offending decency. In fact, a simple little Hercules. If you could do this picture, I would be mightily happy, but, considering the time needed for printing, Fénéon should have it as soon as possible.

Very cordially,
A. Jarry

La 628-E8

Octave Mirbeau wrote a travel book with this title, and Bonnard illustrated it.

"I liked Mirbeau, though we had completely different characters, even opposite, I would say. I first worked on the account of his trip to the Netherlands. He had just bought his first motor car, the 628-E8, and chose the registration plate for the title. I drew an entire suite in the margins. This amused me tremendously, for I greatly appreciate Mirbeau's humor. And the book is filled with it."

Pierre Bonnard

I llustration for an advertisement for Alfred Jarry's novel *The Supermale*, 1902.

The Notebooks

Bonnard often jotted notes and musings in pencil on his drawings as he worked. He also recorded his thoughts in the little blank spaces of his pocket diary, along with daily remarks on the weather, reminders of appointments, and more drawings.

Page from Bonnard's 1941 date book, with a figure sketch, notes on the weather—"fine, foggy"—and appointments, "bank, Renée."

Observations on painting

UNDATED:
The Masters. Their example.
Their flaws. To place them in their time.

A work of art arrests time.

FEBRUARY 7, 1927:
Violet in the grays.
Vermilion in the orange-tinted shadows, on a cold day of fine weather.

APRIL 24, 1929:
Rhetoric in execution: an appeal to the reserves of beauty of form and color, the results of personal observations or the observation of the masters, appearing under your eyes as the brush sets down its strokes.

FEBRUARY 16, 1932:
To represent nature when it is beautiful. Just at its moment of beauty. Beauty is the satisfaction of vision. Vision is satisfied by simplicity and order. Simplicity and order are produced by the division of legible surfaces, the groupings of sympathetic colors, etc.

JANUARY 15, 1934:
One can take great liberties with line, form, proportions, colors as long as the feeling is intelligible and well visible. Intentions are of no account.

1945:
When you cover a surface with colors, you have to be able to replenish your bag of tricks indefinitely, constantly to find new combinations of forms and colors that respond to the needs of the emotion [you are expressing].

Right: sketch-filled pages from various date books.

The painter's houses

Bonnard's art reflects his profound love of privacy and family life. He was extremely attached to his houses and was always inspired by them and their surrounding landscape.

Bonnard at his home in Saint-Germain-en-Laye.

Le Grand-Lemps

First came the family house at Le Grand-Lemps in the Dauphiné. It originally belonged to his grandfather, Michel Bonnard, a farmer and grain merchant, and then to his father, who retired there in his old age. It began as a small, boxlike house, but was enlarged over the years; it was surrounded by some ten acres of woods.

Le Clos, the house at Le Grand-Lemps.

The town of Le Grand-Lemps lies between Lyons and Grenoble, twenty miles east of La Côte-Saint-André...

Under this sky, winter is long. In spring, the earth is soaked with melting snow. But beginning in the month of May, nature awakens from its long sleep and blossoms in the fertile soil...

It was there that Bonnard did his first paintings...he painted landscapes on very small canvases; these have the subtlety of Corot's Italian paintings. But already life and its charms attracted him. The house at Lemps slowly filled with young girls and boys. The graces of childhood smiled in Bonnard's art...

While living in Paris he went there every autumn and sometimes in winter, when too much time had passed since he had seen his mother. She would put him up in a room on the third floor of

the old house, which, with its additions in all directions, had become a studio. Through the north-facing bay window the roofs and belfry of the village could be seen. Farther off in the distance was a line of hills...

The house at Montval

The second house was the one at Montval, outside of Paris. Bonnard was living in the city, but each April, when the peach trees began to blossom, he once more sought nature.

Around 1900 he rented a small house there at the bottom of a very steep lane called rue de la Montagne, which gave onto the main street. There was a small garden bordered by chestnut trees in front of the house, whose facade was broken by three arched doors. It had only one story, with two small, low bedrooms adorned with round bay windows...

La Roulotte

One day he found a new house near Vernon, a town close to Claude Monet's home at Giverny. It had been named Ma Roulette, which means "my camper," or "my caravan." My Camper—what a seductive name to a landscape painter! Yet the house bore its name well. It stood between the river and the road that led from the village of Vernonnet to Pressagny, like a hyphen between road and river...

He described the view from his window, or from the top of the neighboring hill: the pale green and golden fields of early summer; the riverbanks lined with poplars, elms, ash trees, and the silvery patches of willows; the majestic river itself, alive with boats, and blue in the sunshine or lead-gray in the rain...

Villa Castellamare in the winter resort of Arcachon.

Villa Le Bosquet

He lived here and there on the Côte d'Azur—in Saint-Tropez, in the house belonging to [Henri] Manguin, in Antibes, in Grasse. At Le Cannet, in the hills above Cannes, he discovered a modest little pink house amid the posh estates, and called it Le Bosquet, the grove.

Charles Terrasse,
Formes et couleurs (*Forms and Colors*),
1944

Villa Le Bosquet in Le Cannet, on the Côte d'Azur.

Polemics

In 1947 the art historian Christian Zervos, an admirer of Picasso, wrote a harshly critical article on Bonnard in the influential review Cahiers d'art. *This was published on the occasion of a large exhibition of Bonnard's works at the Musée de l'Orangerie in Paris, just a few months after the painter's death.*

Bonnard at Le Cannet in 1945.

Until now, it has been difficult to form an opinion of Bonnard's paintings, since they have been shown only in exhibitions of limited importance. Each time, one got only a fragmentary impression; it was not possible to approach these paintings on an equal footing, or to get to know the peaks and valleys.

The recent retrospective exhibition of Bonnard's work, organized by the Musée de l'Orangerie [in Paris] presents a summary of his oeuvre that leaves nothing out and shows him at an advantage.

I must say in good conscience that I was disappointed by this exhibition. It did not rise to the expectations created by the artist's fame. I admit that it is impossible for me to share the general admiration, not least because of the reverence he inspires…

Bonnard, let us not forget, lived his early working years under the radiant light of Impressionism. He was, in some sense, the last assimilating agent of its aesthetic. But he was a rather weak agent, never finding the strongest vein [of the movement]…

We all know that Impressionism introduced into painting a complex play of atmospheric vibrations, which represent a vivid sense of light. Subtle devices are used to draw everything possible from these [effects], but they are nevertheless always kept subordinate to the formal structure. Unable to make his ideas fit the world of Impressionism, Bonnard helped himself to these atmospheric effects in a manner more excessive than that of Impressionism itself. In his work they ended up dominating form and everything else—so much so that eventually various parts of his paintings are rendered dull and flat…

Two principal tendencies share the new aesthetic that comes out of art's

most audacious conceptions. On one side is Matisse; on the other Cubism, as we already know.

Matisse's enterprise, as remarkable for its bold risks as for its beautiful and appealing aspects, prepares the way for new discoveries with verve and energy. His intertwining of thoughts, forms, and lyrical effusions, ceaselessly refreshed by a marvelous illusionism, has carried art to an elevated realm. His work is instinctive and largely unconscious, but it gave a strong impetus to painting, of which Bonnard was incapable...

Much though I dislike assessing an artist in any way other than in and of himself and according to his own definition; and although I do not wish to make one artist superior to another, nor to use anyone as a weapon, I do so now—but only insofar as the question of Bonnard's oeuvre must be clarified. He must be put in his proper place with respect to Matisse and the better Cubist painters. Surprisingly, he lived during one of the most intense periods in the history of art without having any instinctive sense of what was going on. None of the myriad investigations, anxieties, explorations, or extraordinary discoveries of this period awakened him. No hint resurfaced in his work of the adventurous experiments, rapid growth of power and influence, or honest, vital originality of the men with whom he lived side by side...

Thus Bonnard seems to me an artist with no junk elements, or nearly so, but also with no superabundance. If he pos-

Z ervos's question, "Is Pierre Bonnard a great painter?" provoked the indignation of Matisse, who scrawled on a copy of the article: "Yes! I certify that Pierre Bonnard is a great painter for today and assuredly for the future. Henri Matisse Jan. '48."

sesses some fine qualities, he is nonetheless entirely lacking in breadth of mind and the insight of genius. His inspiration is not spirited enough; he never falls under the influence of an exaltation of the senses, and he cannot abandon himself to violent internal conflicts nor the urge to confront. Where he should strike a decisive blow, he glides...

Undoubtedly, there will be many who will think I am pitifully mistaken about Bonnard. I apologize for persisting in my beliefs.

Christian Zervos,
"Pierre Bonnard: Est-il un grand peintre?"
Cahiers d'art 22, 1947

Further Reading

For further bibliography, see *Bonnard: The Late Paintings,* Centre Georges Pompidou, Paris; Phillips Collection, Washington, D.C.; and Dallas Museum of Art, 1984, exh. cat.

CATALOGUES RAISONNÉS

PAINTINGS
Dauberville, J. and H. *Bonnard: Catalogue raisonné de l'oeuvre peint,* 1966, 1968, 1973, 1974.

PRINTS
Bouvet, F. *Bonnard: L'Oeuvre gravé: Catalogue complet,* 1981.
Roger-Marx, C. *Bonnard lithographe,* 1952.

PHOTOGRAPHS
Heilbrun, F., and Néagu, P. *Pierre Bonnard photographe,* 1987.

ILLUSTRATIONS
Terrasse, A. *Pierre Bonnard illustrateur,* 1988.

BOOKS AND JOURNAL ARTICLES

Amoureux, G. *L'Univers de Bonnard,* 1985.

Beer, F.-J., Gillet, L., and Cogniat, R. *Pierre Bonnard,* 1947.

Bonnard and His Environment, Museum of Modern Art, New York, October 7–November 29, 1964; Art Institute of Chicago, January 8–February 28, 1965; Los Angeles County Museum of Art, March 31–May 31, 1965. Exh. cat.

Bonnard dans sa lumière, Fondation Maeght, Saint-Paul-de-Vence, France, July 18–September 28, 1975. Exh. cat.

"Bonnard," *Formes et couleurs,* no. 22, 1944.

"Bonnard," *Le Point,* special issue 24, January 1943.

Bonnard: The Late Paintings, Centre Georges Pompidou, Paris; Phillips Collection, Washington, D.C.; and Dallas Museum of Art, 1984. Exh. cat.

Bonnard, National Museum of Western Art, Tokyo, March 20–May 5; National Museum of Modern Art, Kyoto, May 11–June 16, 1968. Exh. cat.

Bonnard, Ny Carlsberg Glyptotek, Copenhagen, May 1947. Exh. cat.

Bonnard, Orangerie des Tuileries, Paris, October–November 1947. Exh. cat.

Bonnard, Tate Gallery, London; Museum of Modern Art, New York, 1998. Exh. cat.

Bouvier, M. "Pierre Bonnard revient à la litho…," *Comoedia,* January 23, 1943.

Clair, J. *Bonnard,* 1985.

Cogeval, G. *Bonnard,* 1993.

Cogniat, R. *Bonnard,* 1968, 1977.

————. "Leurs débuts: Pierre Bonnard," *Les Nouvelles littéraires,* July 29, 1933.

Coquiot, G. *Bonnard,* 1922.

"Couleur de Bonnard," *Verve,* vol. 5, no. 17–18, 1947.

Courthion, P. *Bonnard, peintre du merveilleux,* 1945.

————. "Impromptus—Pierre Bonnard," *Les Nouvelles littéraires,* June 24, 1933.

Cousturier, L. "Pierre Bonnard," *L'Art décoratif,* no. 180, December 20, 1912.

Denis, M. "L'Epoque du symbolisme," *Gazette des Beaux-Arts,* March, 1934.

Diehl, G. "Pierre Bonnard dans son univers enchanté," *Comoedia,* July 10, 1943.

————. "Fidélité de Pierre Bonnard," *Comoedia,* April 15, 1944.

————. "Les Problèmes de la peinture," *Confluences,* 1945.

Fermigier, A. *Pierre Bonnard,* 1969.

Flament, A. "Les Silences du peintre Bonnard," *La Revue des deux mondes,* no. 78, December 15, 1943.

Fosca, F. *Bonnard,* 1919.

Gallimard, G. "Oeuvres récentes de Bonnard," *La Nouvelle revue française,* no. 44, August 1912.

Giverny, A. "Bonnard," *La France libre,* May 15, 1943.

Hommage à Bonnard, Galerie des Beaux-Arts, Bordeaux, May 10–August 25, 1985. Exh. cat.

Hommage à Bonnard, Galerie Bernheim-Jeune, Paris, May–July 1956. Exh. cat.

Hyman, T. *Bonnard,* 1998.

Kober, J. "Bonnard et les écoles," *L'Arche,* no. 6, February 1941.

————. "Hommage," *Derrière le miroir,* February–March 1947.

Lassaigne, J. "Hommage à Bonnard," *La Maison française,* no. 1, 1946.

Lhote, A. "Bonnard," *La Nouvelle revue française,* January 1, 1912.

————. "Irréalisme et Surréalisme," *La Nouvelle revue française,* August 1933.

Morel, M. "Un Primitif parmi nous," *Les Editions de France,* July 1942.

Natanson, T. *Le Bonnard que je propose,* 1951.

Pierre Bonnard: A Retrospective Exhibition, Museum of Art, Cleveland, March 3–April 11, 1948; Museum of Modern Art, New York, May 11–September 6, 1948. Exh. cat.

Pierre Bonnard: Centenaire de sa naissance, Orangerie des Tuileries, Paris, January 13–April 15, 1967. Exh. cat.

Pierre Bonnard: Gemälde, Aquarelle, Zeichnungen, und Druckgraphik, Kunstverein, Hamburg, February 6–April 5, 1970. Exh. cat.

Pierre Bonnard, Kunsthaus, Zurich, June 6–July 24, 1949. Exh. cat.

"Pierre Bonnard," *Les Publications techniques et artistiques,* 1945.

Pierre Bonnard, Palazzo della Permanente, Milan, April–May 1955. Exh. cat.

Pierre Bonnard, Royal Academy of Arts, London, January 6–March 6, 1966. Exh. cat.

Pierre Bonnard: Svensk ägo, Svensk Fransk Konstgalleriet, Stockholm, September 1947. Exh. cat.

Pierre Bonnard, Stedelijk Museum, Amsterdam, June–July 1947. Exh. cat.

Rewald, J. "For Pierre Bonnard on His Seventy-Fifth Birthday," *Art News,* October 1, 1942.

Rydbeck, I. "Hos Bonnard i Deauville," *Konstrevy,* no. 4, 1937.

Sterling, C. "Bonnard," *L'Amour de l'art,* April 1933.

Sutton, D. *Bonnard,* 1957.

Terrasse, A. *Bonnard,* 1964, 1967, 1988.

Terrasse, C. *Bonnard,* 1927.

Terrasse, M. *Bonnard: Du dessin au tableau,* 1996.

———. *Bonnard at Le Cannet,* 1987.

Vaillant, A. *Bonnard ou le bonheur de voir,* 1965.

Watkins, N. *Bonnard,* 1994.

Werth, L. *Bonnard,* 1919, 1923.

List of Illustrations

Index

Photograph Credits

AKG, London: 24b. All rights reserved: 14b, 15, 16b–17b, 18a, 18b–19b, 24a, 25, 28a, 36, 37c, 60, 92, 119, 122, 125, 126, 132l, 132r, 133a, 133b, 134. Archivio Scala, Florence: 42, 62b. Asahi Brewery Ltd, Japan: 101. Bibliothèque Nationale de France, Paris: 11, 110b, 130–31. © Mme Brassaï, Paris: 105a. Bridgeman Art Library, London/Paris: 27a. Bulloz, Paris: 93. Christie's, New York: 77. Collection Thyssen-Bornemisza, Madrid: 58. Fondation Bemberg, Toulouse/photo J.-M. Routhier: 108. Galerie Berès, Paris/photo Patrick Léger: 27b. Galerie Bernheim-Jeune, Paris: 3, 90b. Galerie Jan Krugier, Ditescheim & Cie, Geneva: 69, 89, 107. Galerie Paul Pétridès, Paris: 53b. Galerie Schmit, Paris: 54a, 88l. Giraudon, Paris: 5, 64, 66a, 67, 100b, 110a. Institut Wildenstein, Paris: front cover, 82b. Kunstmuseum, Winterthur, Switzerland: back cover. Magnum, Paris: 102l, 102r, 106a. Metropolitan Museum of Art, New York: 63, 68a. Musée de l'Annonciade, Saint-Tropez: 2. Musée des Beaux-Arts, Grenoble: 98–99. Musée National d'Art Moderne, Centre Georges Pompidou, Paris: 6, 7, 111, 112. Museum of Modern Art, New York: 95, 97. Musées Royaux des Beaux-Arts de Belgique, Brussels: 49. National Gallery of Art, Washington, D.C./photo Richard Carafelli: 32. The Phillips Collection, Washington, D.C.: 70–71, 80a. Photothèque des Musées de la Ville de Paris: 8–9. Private collection: spine, 1, 4, 12, 14a, 16a, 20, 21b, 37a, 37br, 39b, 43, 48, 50a, 52, 53a, 54b, 55a, 55b, 56, 65b, 72a, 73a, 73b, 76a, 78, 91, 94a, 96, 104, 105b, 106b, 109, 115, 116, 117, 120–21, 122–24, 127, 128, 129a, 129b. Private collection/photo Patrick Léger: 13, 14b, 15, 19r, 21a, 30a, 30b, 33a, 33b, 34l, 34r, 35a, 35b, 37bl, 38, 39b, 44l, 44r, 45al, 45ar, 45b, 50c, 50b, 59a, 61, 62a, 65a, 66b, 68b, 72b, 75, 76b, 79, 80b–81b, 82a, 83, 84–85, 87a, 88r, 90a, 103bl and br. Réunion des Musées Nationaux, Paris: 17a, 22l, 22r, 23l, 23r, 26, 28b, 29, 31, 39al, 39ar, 40, 41, 46a, 46b, 47a, 47c, 47b, 48, 51, 57, 59b, 113, 114. Scottish National Museum of Modern Art, Edinburgh: 81a. Henri Matisse © Succession Matisse: 87a, 103a, 118, 135. Tate Gallery, London: 87b. Von der Heydt Museum, Wuppertal: 86.

Text Credits

Richard Howard's translations of Julien Gracq, quoted on page 114, and of the Bonnard-Matisse letters reprinted on pages 118–19, are from *Bonnard/Matisse: Letters between Friends,* introduction by Antoine Terrasse, English translation copyright © 1992 Harry N. Abrams, Inc., New York. Jean-Marie Clarke's translations reprinted on pages 128–29 are from *Pierre Bonnard Illustrator,* Harry N. Abrams, Inc., New York, 1989, © 1988 Editions Adam Biro.

Antoine Terrasse, author and exhibition curator,
has published *Seurat* (1976), *Degas et la photographie* (1983),
De Cézanne à Matisse (1980), *Bonnard illustrateur*
(1988), *Les Nabis,* with Claire Frèches-Thory (1990),
La Correspondance Bonnard-Matisse, with Jean Clair (1990),
Pont-Aven: L'Ecole buissonnière (1992), and other works
on Pierre Bonnard, Maurice Denis, and the Impressionists.
He is a great-nephew of Bonnard.

Translated from the French by Laurel Hirsch

For Harry N. Abrams, Inc.
Editor: Eve Sinaiko
Typographic designers: Elissa Ichiyasu, Tina Thompson, Dana Sloan
Cover designer: Dana Sloan
Text permissions: Barbara Lyons

Library of Congress Cataloging-in-Publication Data

Terrasse, Antoine.
 [Bonnard. English]
 Bonnard : shimmering color / Antoine Terrasse.
 p. cm. — (Discoveries)·
 Includes bibliographical references and index.
 ISBN 0–8109–2867–1 (pbk.)
 1. Bonnard, Pierre, 1867–1947. 2. Painters—France—Biography. I. Bonnard,
Pierre, 1867–1947. II. Title. III. Discoveries (New York, N.Y.)
ND553.B65 T3913 2000 00–26253
759.4—dc21

Printed and bound in Italy by Editoriale Lloyd, Trieste